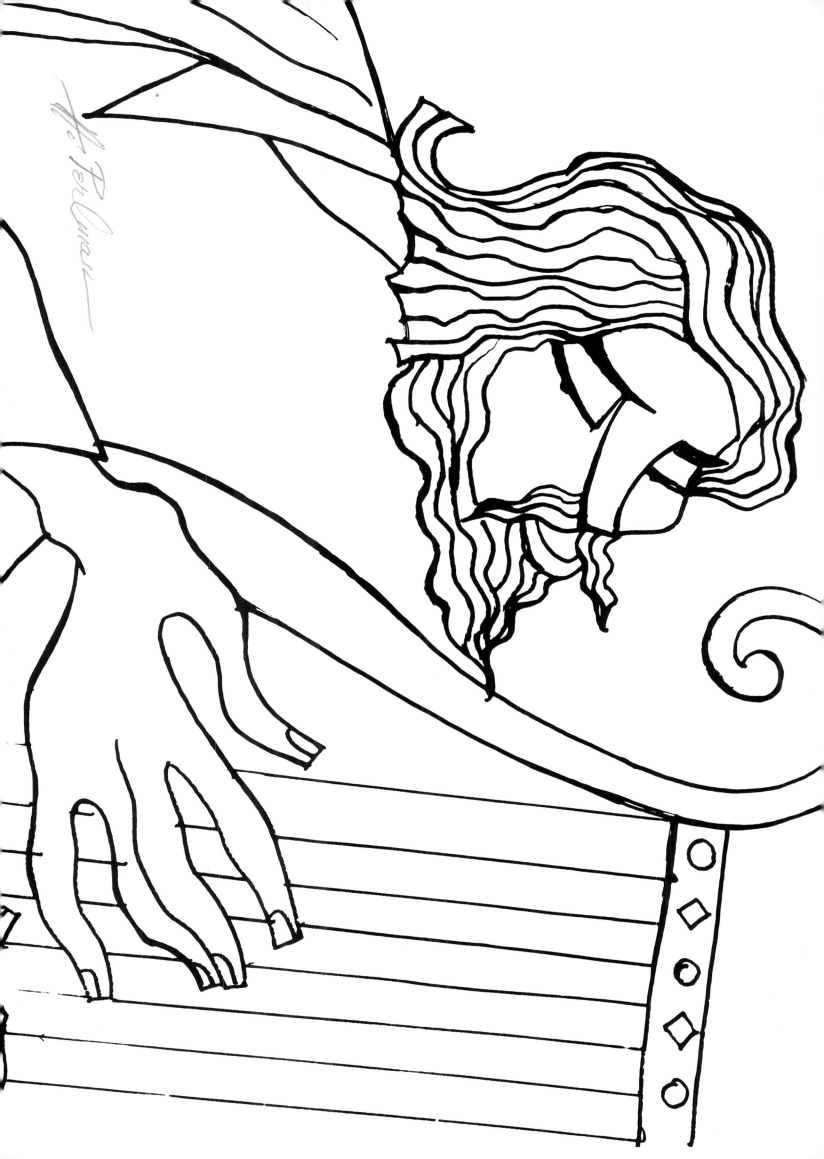

Herman Perlman

HIS LIFE AND ART

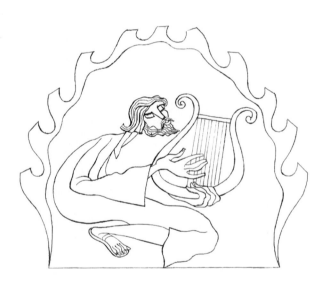

By
Regina Greenspun

Bartleby Press

Photographs of Perlman's glass
sculptures by Fred Ward, Black Star,
Bethesda, Maryland and John Troha, Black
Star, Potomac, Maryland

Photos on pages 31, 52 & 53 courtesy
of Ida Jervis

Design by Invisions, Ltd.
Washington, D.C.

Printed by Braun-Brumfield, Inc.
Ann Arbor, Michigan

Published by Bartleby Press, Inc.
Box 1516, Silver Spring, Maryland 20902

Library of Congress Catalog Card
Number 81-85005

ISBN 0-910155-00-3

The Author

Regina Greenspun, M.F.A., studied art
history at Harvard University. Her
interest in Jewish studies led her to write
a thesis on the history of synagogue
architecture. For many years she has
been a religious educator at the Washing-
ton Hebrew Congregation. Mrs.
Greenspun served as the Chairman of
the Committee on Temple Art of the
Mid-Atlantic Council of the Union of
American Hebrew Congregations. She
has been an art consultant to many col-
lectors in the Washington area. Mrs.
Greenspun is also well-known as a
leader in the movement to educate
gifted and talented students. She resides
in Bethesda, Maryland.

CONTENTS

Dedication 7
Illustrated Biography 11
The Caricatures 39
The Glass Sculptures 52
Collections 120
Award Recipients 121
Exhibitions 122
Permanent Installations 125
Index 126

This book is dedicated to my beloved wife Sara.

She graced every exhibit of my glass art, as we travelled throughout the USA and three times to Israel. A "Woman of Valor," Sara obtained favour in the sight of all who looked upon her.

Herman Perlman

Sara Shuster Perlman, 1913-1979

Smiling she bids you enter,
Artist-mate with soulful eyes,
Reaching out to spread more beauty,
Aiming for the starry skies…
Healing aches and gently soothing,
* banning care and stilling sighs.*

Hand-in-hand they walked life's pathways,
Every day their bonds renewed;
Rivulets of human kindness
Made a magic mellow mood.
Angel voices all acclaim her,
Nature nods, with awe imbued.

Partners always in endeavors,
Ever working side-by-side;
Rising up to meet the challenge,
Life became a lofty ride.
May her spirit live forever
And her mem'ry hallowed be:
Name her name and know that always
* she is blessed and so are we.*

Poem by Shulamith Subar, 1979

Herman Perlman's life as an artist began when, as an immigrant school boy, he communicated with his English-speaking teacher by drawing.

This biography, written during the eighth decade of a still productive life, will bring to his friends and admirers, the story of Perlman's career. From the theatrical and political caricatures which he did in the 1930's, to the glass sculptures which brought him renown in the 1960's and 1970's, Perlman's work has been characterized by myriad variations in its strong linear quality and by a combination of reverence and humor in his approach to subject matter.

Perlman's life story is told, from his childhood in Russia, through his struggles as a young man making his way in depression-beset America, to his maturity as an artist with a unique medium—glass.

Marvin Perlman, the artist's son, has been a hard-working and invaluable partner in the effort to bring this book forth. My thanks also to Shirley Pollin, the artist's daughter. To Herman, who has shared his memories with me, my love and thanks.

Regina Greenspun
April, 1982

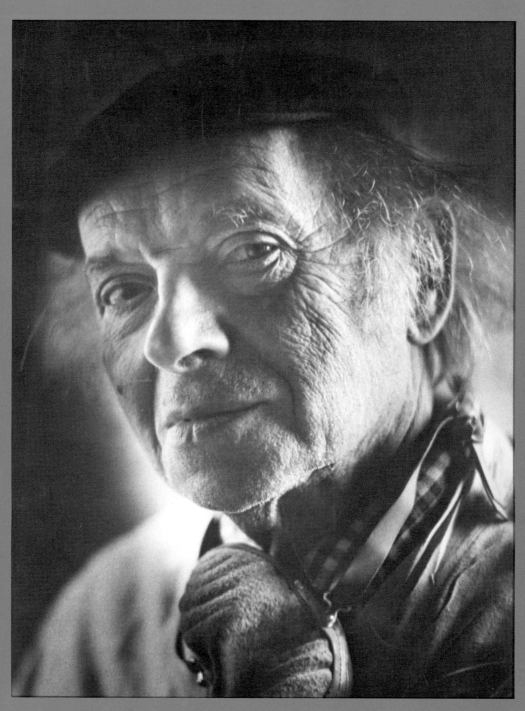

Herman Perlman, 1977.

Herman Perlman came to America from Eastern Europe, as did many immigrants during the early years of the 20th century. He was born in 1904 in the shtetl community of Roschist, a Polish town in Volyn province, near the Russian border city of Lutsk. When he was a very young child, Herman was taken to live in the Russian city of Rodomyshl, near Kiev. His father, Israel Perlman, worked in a woolen mill in Rodomyshl. Israel was promoted from weaver to office clerk because of his ability to read and write in Polish and Russian as well as in Yiddish. Herman's mother, Raysl Sitnick Perlman, daughter of a Rabbi, operated a small grocery store.

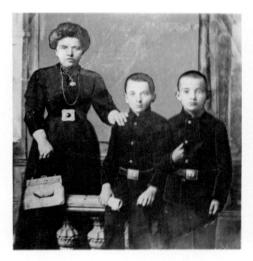

Herman and Max Perlman with their mother, Raysl. The boys wear their Russian school uniforms. Rodomyshl, 1911.

Herman's first language was Russian, which he learned from the girl who took care of him while both his parents worked. He and his older brother Max saw their parents only on the long Sabbath weekends. They spent their days at play along the riverbank which flowed through the lower part of the city. Herman was only six or seven years old when he made his own ice skates from wood and wire, in order to skate on the river with the Russian children. On one occasion, he and some friends broke through the ice and were saved by a man who left the scene before he could be thanked.

A Hebrew teacher, known as a "Melamud," came to the house to teach Max and Herman the Hebrew language and the prayers which were part of their life as Orthodox Jews. Unlike other children of the Jewish community, Max and Herman did not attend the local "cheder," or Hebrew school. Their father, through the influence of his employer, the mill-owner Orenstein, was able to enter first Max, then Herman, in the Russian school.

Herman entered school in the fall of 1909, at age five, having passed an intelligence test administered to new students. The school was like a military academy. Even the youngest students wore uniforms of black wool, styled like those of Russian soldiers. Their shirts were bright red and they carried wooden rifles. Much of the curriculum was directed toward the military life, but that seems to have had little influence on young Herman. It was the long hours spent practicing penmanship, row upon row of fancy letters, which had a lasting influence upon the boy.

Israel Perlman was worried about the future. Not only did war seem imminent in 1910, but also the desire for social change was influencing workers at the Orenstein mill. Modernization of the manufacturing process had brought about a long strike and the laying off of many employees. Perlman, who was better educated than the rest, retained his job; in fact, he was promoted. He was able to rent a spacious brick home for his family. But the communist workers in the Jewish community harassed him, not only at the factory but also at his home, which they insisted upon using as a meeting place.

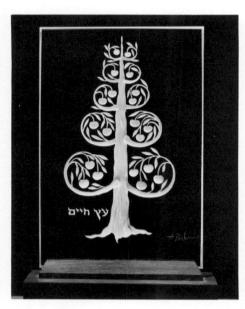

"Etz Hayim"
The Tree of Life

Israel decided to go to America, to which so many Jews had emigrated and from which stories of freedom, opportunity and success were coming through the mail. Raysl's brother-in-law, Meyer Bikel, had been in America for three years. Israel left in 1912, joining Bikel in Columbus, Ohio.

Herman and Max moved with their Mother to Kolk, the Polish shtetl where she had grown up and where her father and sister lived. Kolk was a small town with unpaved streets and primitive wooden houses. The change was difficult for the Perlmans. They missed their home in Rodomyshl, as well as the river and parks, the cobblestone streets and the beautiful main square with its churches and municipal buildings.

Rabbi Meyer Sitnick, their grandfather, was the director of a small Yeshiva for advanced students of the Talmud. He was horrified that his two grandsons spoke Russian, and forbade it in his home. He also refused to allow them to wear their Russian school uniforms; the military attire was out of the question for Jewish children in a shtetl.

The boys attended the local cheder, where they memorized long passages in Hebrew and Aramaic from the Torah and Talmud. They celebrated the holidays in a totally Jewish environment; Herman later reminisced about Purim, when he and Max went from house to house in costume, delivering gifts of baked delicacies.

A visit to their uncle, Moishe Sitnick, in the city of Rovno, gave Herman his first opportunity to see the drawings of a talented amateur artist. Moishe's apartment walls were covered with drawings of his friends. Herman, eight years old at the time, loved the pictures; he did not realize then that he would turn to drawing as his life's work.

At last the day came when Herman's father was able to send for the family. It was already 1914, and they were fortunate to be leaving before the beginning of the war. Raysl and the two boys travelled by train through Lithuania to the Estonian port of Libau. There they boarded the "Roccia" for the eleven-day crossing which would bring them to America.

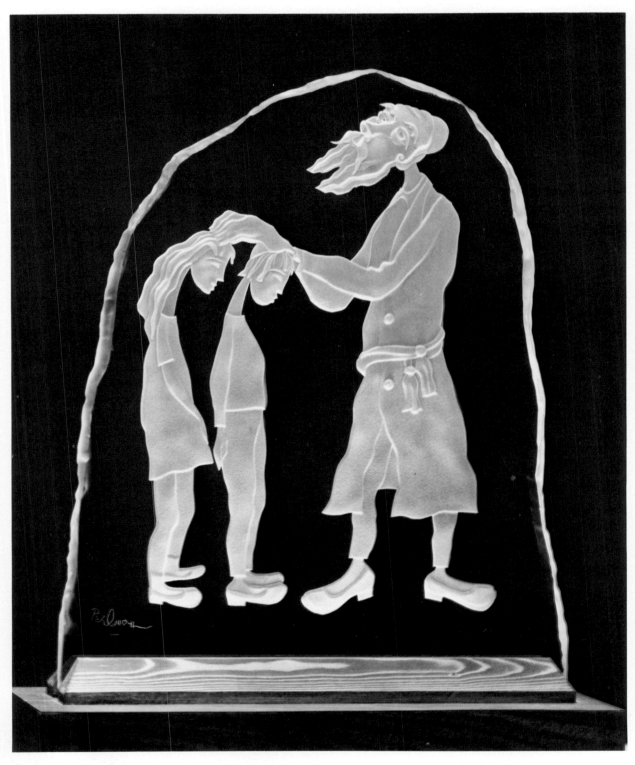

The Zayde's Blessing

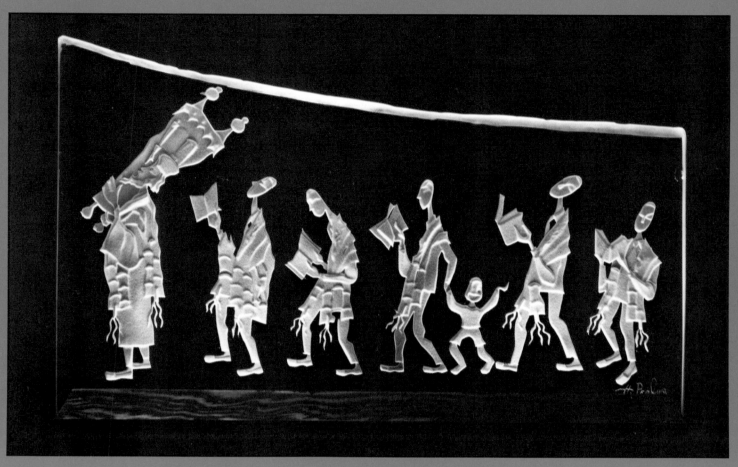

Procession

Herman arrived in Columbus, Ohio, in March 1914, just before his tenth birthday. His father had a home ready for the family, in a neighborhood of German immigrant families. Herman and Max were immediately enrolled in the Beck Street School. Their teachers used German-speaking classmates to translate for the Yiddish-speaking newcomers. But the adjustment to a new language was difficult, and Herman was badly treated by the German boys, who considered the "greenhorn" fair game for tricks and teasing.

Joseph and Benjamin
(Temple Oheb Shalom, Baltimore)

Fortunately, summer and vacation time came. The family moved to a neighborhood where there was a large Jewish population, including children who spoke both Yiddish and English. Herman was able to travel with his father during the week, peddling housewares and collecting junk in the countryside around Columbus. They slept in farmhouses and often were invited to eat with their host families. Every Friday Herman and his father returned home laden with fruits and vegetables given to them by their new American acquaintances.

The Sabbath was the core of the Perlman family's Jewish experience. Raysl prepared a festive meal for her husband and sons, and for the two boarders who lived with them while World War I prevented their families from leaving Poland. The men and boys went to services at a nearby synagogue, returning home to eat and to sing "z'mirot," traditional songs in Hebrew and Yiddish. There was much visiting among the families who lived on Elmwood Street, and the Perlmans shared the joys and sorrows of their neighbors.

In September 1914, Herman was enrolled in the third grade at the Fulton Street School, where he was to remain until the age of sixteen. During these years, he was encouraged by the art teacher to develop his talent for drawing.

Miss Hillelson was the art and music teacher at the Fulton Street School. When ten-year-old Herman Perlman came into her class, his knowledge of English was very limited. She helped him with his language skills by drawing things on the blackboard. She encouraged him to sketch objects when his English vocabulary was insufficient. Very quickly, she realized that Herman's talents were special, and she encouraged him to draw for the sake of developing his artistic gifts as well as for enlarging his knowledge of English.

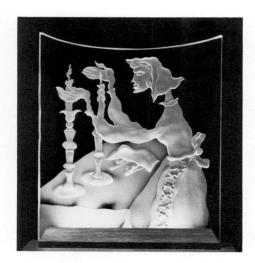

"Licht Benchen"
Blessing the Sabbath Candles

Herman became very interested in drawing. Faces were his specialty. He began to copy faces from the newsphotos of European and American war heroes.

The tragic death of his eighteen-year-old brother Max, in the influenza epidemic of 1918, plunged Herman into a year of "shiva," the period of Jewish mourning. During this time, he was forbidden by tradition to sing. Miss Hillelson allowed him to draw during music class. His works, mostly pencil drawings, were displayed throughout the school. In 1919 Miss Hillelson entered some of them in the Ohio State Scholastic Art Contest. Two of Herman's drawings received Honorable Mention and were displayed in the Ohio State Board of Education building. Seeing his works on exhibition, Herman decided that he wanted to be an artist.

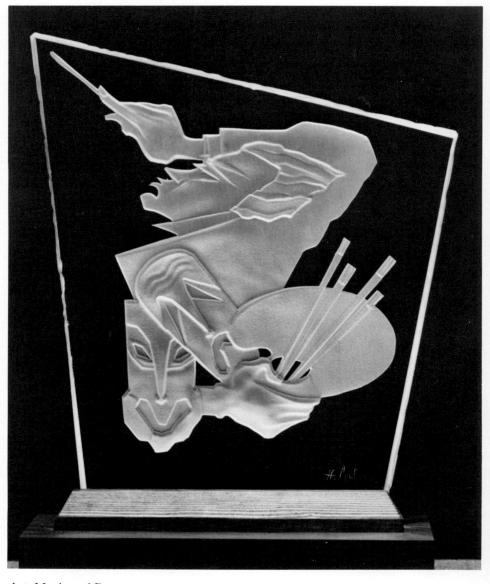

Art, Music and Drama

Herman was an independent boy. He had been earning money since the age of eleven, when he began to sell newspapers in front of the Lazarus Department Store. He also received one dollar an evening for setting up bowling pins at the Elks Club. At the age of fourteen, during World War I, he earned $45.00 a week working for the summer in a defense plant which made electrical equipment. He and a group of friends established their own business for a while, installing electric doorbells.

Life had its lighter moments, too. On Sunday evenings he often attended the Majestic Theatre performances, where an orchestra played the music of Victor Herbert and the brothers Strauss. There were dances at the Schonthal Community Center, and for the intellectually curious Herman and his friends, there was a science laboratory provided by Joseph Schonthal, founder of the Center.

In 1920, after only a half year of high school, Herman dropped out of school. He was sixteen years old and ready to earn his living. Hoping to get a job as an artist, he made the rounds of art studios and sign shops. But it was the end of the war, and jobs were scarce. He was forced to accept the only employment he could find—delivering meat for a kosher butcher. His working hours were 3 A.M. to 11 A.M.

This job gave Herman plenty of time to work at his electrical interests. He continued to use the facilities at the Schonthal Center and he worked at home in a little room which was part of the stable behind his house. There he made telephones, designed electrical circuits and built a crystal radio. At the age of nineteen he became an electrician's helper.

The death of Herman's brother Max in 1918 had left a bitter residue in the Perlman family. Israel and Raysl quarrelled bitterly. Despite the best efforts of friends and relatives, the couple was divorced. Raysl decided to move east to be near her cousins. In 1924 she and Herman left Columbus. He did not return again until 1966, when an exhibition of his work was presented in the Jewish Community Center there.

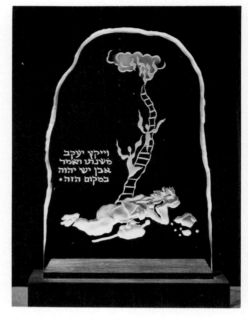

Jacob's Dream
"And Jacob awakened from his sleep, saying: Surely the Lord is present in this place and I knew it not."
Genesis XXVIII 7-16

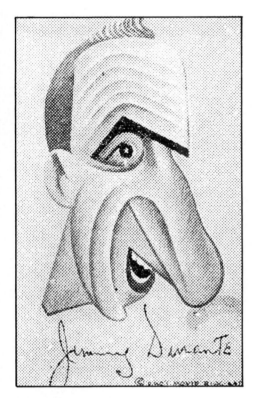

Jimmy Durante, Comedian

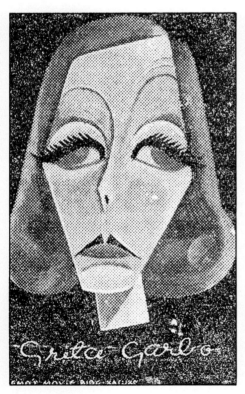

Greta Garbo, Actress

H erman and his mother lived in Washington, D.C. for several months, until Raysl decided to settle in Baltimore. She purchased a house which contained a small store, and Herman left his job with a Washington electrical contractor in order to work in the grocery with his mother. However, the store's receipts could not support them both; Herman supplemented their income by working in the evening at a delicatessen.

Herman had not really pursued his interest in art since leaving school. But the desire to draw was rekindled during a rainy Rosh Hashanah. He was unable to go to the synagogue and spent the holiday at home, sketching faces from the newspapers, just as he had done in Columbus more than four years before.

Determined, once more, to pursue a career in art, Herman enrolled in the Maryland Institute of Art. He studied design, drawing animals in stylized forms and creating the flattened effects of poster art. Working in a variety of media and in both color and black and white, Herman prepared himself for work in a commercial art studio.

Opportunity came to Herman one evening in 1927, when Mr. Louis Janof walked into the delicatessen for a sandwich. He invited Herman to sit with him while he ate and he mentioned his work as the art director of *The Washington Post*. Herman took the opportunity to show this stranger some drawings which he had on hand, and Janof was impressed. He invited the young art student to visit him at the *Post* the next time he was in Washington.

Two weeks later, Herman went to Washington. Janof showed him around the studio, where a staff of twenty-nine artists worked on advertisements and layouts. When Herman expressed a desire to work for Janof, he was offered the only opening available at the time—a position as an apprentice photo retoucher on the 5-11 P.M. shift. Although the $15 per week salary was $30 a week less than he had been earning at the delicatessen, Herman accepted the job. It was his first opportunity to work in a professional art studio.

Raysl Perlman sold everything, and she and Herman moved to Washington.

Perlman's job as a photo-retoucher at the *Post* was rather boring. He had to work with an airbrush to improve the quality of news photos which were needed for the morning edition. He also did decorative borders for the society pages and occasional small sketches and free-hand lettering.

Because he worked at night, Perlman was able to attend classes at the Corcoran School of Art during the day. Unlike the Maryland Institute in Baltimore, where most of the students were preparing for careers in commercial art, the Corcoran was a school which took a very classic approach to the arts. Everyone drew in charcoal from plaster casts of antique statuary. A few times each month, a model was brought in so that classes in life drawing could be offered. Most of the students had only a dilettante's interest in art. Perlman felt he was not learning anything.

A chance meeting with Tony Sarge resulted in a new stage in Perlman's career. Sarge, an illustrator for *The Saturday Evening Post*, came to Washington to provide sketches for a series on farm life which was to appear in *The Washington Post*. He invited Perlman to lunch and they discussed the younger man's dissatisfaction with the lack of challenge in his work at the *Post* and his uncreative classes at the Corcoran School.

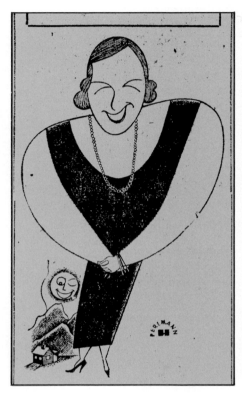

Kate Smith, Singer

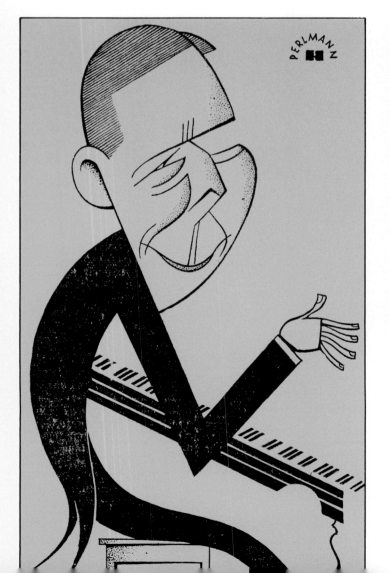

Herb Williams, Chaz Chase and Jack Benny in Earl Carroll's "Vanities."

George Arliss, Actor

19

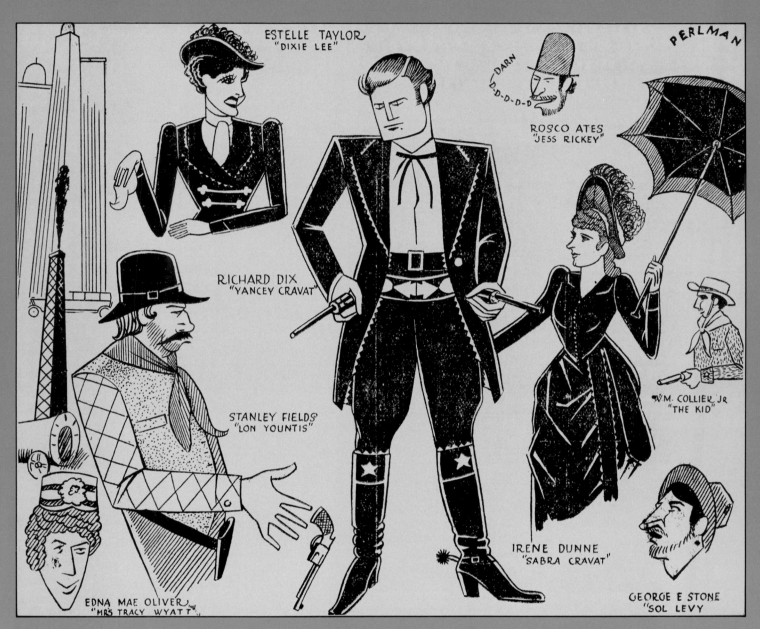

"Cimarron"
This was the first of many large movie
caricatures which Perlman drew for the
"Washington Post."
(Like many of the caricatures reproduced
in this book, "Cimarron" is tattered,
brittle and stained after forty-five years
in an old scrapbook.)

Sarge encouraged Perlman to try a new approach to drawing. He flung his jacket over a chair and pointed out the way the folds of the material lay, and the effects of light and shadow on the surface. He advised Perlman to study the jacket and try to remember it, so that when he was at home he could draw it from memory. "Don't draw what you see. Draw what you saw!" was Sarge's message.

Perlman tried the new approach to drawing, with great enthusiasm. He dropped his classes at the Corcoran School and practiced drawing from memory, first with objects and then with faces. Studying the men with whom he worked, Perlman began to develop a style of portraiture which was recognizable, yet distorted. He brought his drawings into the studio and attracted both praise and encouragement from the staff.

Perlman's drawings were brought to the attention of the publisher, and he began to receive assignments to prepare caricatures of theatrical personalities and of important visitors to Washington. His drawings of stage and screen stars became an important feature of the *Post*'s coverage of popular entertainment. However, this did not prevent Perlman from being laid off in 1930, when advertising revenues were down.

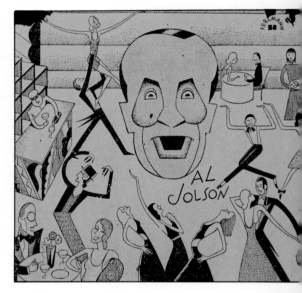

Al Jolson, Singer

Fortunately, he was not out of work for very long. The theatre owners of Washington missed the publicity which they had received when Perlman caricatures featured their performers. They contracted to buy drawings directly from Perlman for use in their advertising campaigns. The fees which he received for this work were considerably higher than the salary which he had been receiving from *The Washington Post*. When, after a few months, he was rehired by the newspaper, he continued with this free-lance work.

In the spring of 1931, Perlman was sent to Philadelphia to preview a George M. Kaufman musical, "Merry Go Round," starring Ginger Rogers and Fred and Adele Astaire. He was to draw caricatures in preparation for the opening in Washington. Taking the opportunity to visit with relatives whom he had not seen since 1927, Perlman met Sara Shuster, his cousin's sister-in-law. He was attracted to her immediately, and after a few more visits he proposed and was accepted. Although he worried about his ability to support a wife (his mother was not entirely self-supporting), and he was concerned about Sara's youth (she became eighteen in October), love overcame his qualms. Encouraged by his mother and by Sara's eldest sister, the couple were married on December 2, 1931 by Rabbi Rivkin of Baltimore's Lloyd Street Synagogue.

H.G. Wells, Author

Perlman was married only a few weeks when he was again laid off by the *Post*. He found freelance work in addition to his caricaturing, and he and Sara had a very happy year. Their daughter Shirley was born in 1932, and Perlman received a commission from Metro Goldwyn Mayer which gave nationwide exposure to his work.

MGM commissioned Perlman to do the press book for "Rasputin and the Empress." This movie, which starred Ethel, John and Lionel Barrymore, was one of the important releases of 1932. The press book was sent to every theatre in which the movie was to appear. It contained illustrations of the posters, flyers, programs and advertisements which the theatre managers could order from MGM. Most of the works in the press book were line drawings which could be reproduced easily in black and white; but Perlman also prepared paintings of the Barrymores in their Russian costumes.

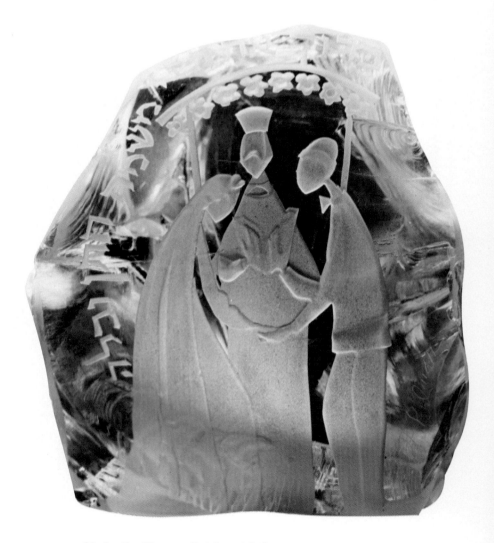

Under the Chuppa: Rejoice with the Bride and Groom

The Mitzvah Tantz—Dance

A t Chasidic weddings, the *mitzvah tantz* follows the *sheva brachoth*. The rabbi dances with the bride while each holds the corner of a handkerchief or *gartel* (Chasidic belt). The rabbi dances with closed eyes, elevating his thoughts to the relationship between God and Israel, which is compared to the relationship between the groom and the bride. In the words of the prophet: "As the bridegroom rejoices over the bride, so shall thy God rejoice over thee." (*Isaiah* 62:5) Afterwards, members of the family dance with the bride, again holding the handkerchief, as only the groom and the bride's father are permitted to touch the bride. The *mitzvah tantz* is accompanied by various songs, especially the *Aisheth Chayil* (woman of valour), the hymn for the Jewish wife composed by King Solomon (*Proverbs* 31).

270 *MITZVAH TANTZ*
Steuben, carved glass
By Herman Perlman
America
Courtesy of Mr. and Mrs. L. L. Gildesgame

271 *MITZVAH TANTZ*
Lithograph
By Moishe Bernstein
Israel
Courtesy of Museum of Jewish Art, Jerusalem

272 *MITZVAH TANTZ*
Etching
By A. Krol
Paris
Courtesy of Museum of Jewish Art, Jerusalem

273 *MITZVAH TANTZ*
Colored lithograph
By Ira Moskowitz
1975
Courtesy of the artist

274 *AISHETH CHAYIL*
Colored lithograph
Illustrating the entire hymn
By Shalom Zaigermacher
Safed
Private collection, N.Y.

Marrow Donor Sought for Md. Patient

By Claudia Levy
Washington Post Staff Writer

Allison Atlas thought it was her studies at New York University, and then her summer job in Gaithersburg, that were draining her of energy this year.

But one hot afternoon in August, the 20-year-old Bethesda resident collapsed, without warning. Within days, her stunned family learned that she faced death, possibly in months, from a type of leukemia that rarely strikes people under 60.

Today, the possibility of finding a bone marrow donor among family and friends exhausted, a quickly formed Friends of Allison is widening its search through a mass appeal that has been undertaken by synagogues and Jewish organizations.

Atlas's family used Jewish organizations because Atlas is Jewish and the best chance of finding a suitable donor outside of her own family is within her "own ethnic gene pool," said Fern Ingber, a friend and former director of the youth group at Adas Israel Congregation in the District.

For unrelated individuals, the chance of finding a match is 1 in 20,000, said Bernice Loiacona, who heads the donor center at the National Institutes of Health. Narrowing that search to donors with some

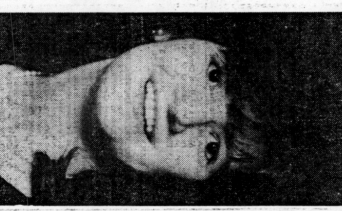

ALLISON ATLAS
... "I can't do a lot"

similarity in ancestry reduces the odds to 1 in 10,000 to 15,000, she said.

Nationally, Atlas is one of about 11,000 people who need bone marrow transplants and whose family members are not suitable donors, said Tammy Brown, a spokeswoman for the Life-Savers Foundation of America, a California-based organization that helps search for donors.

One of every four persons who need a transplant can be matched with a sibling or other family member, she said. The foundation is searching for donors for 125 people like Atlas who need transplants immediately.

Local volunteers said hundreds of potential donors solicited by regional mailings are expected from 3 to 8 p.m. today at the Jewish Community Center in Rockville to give small blood samples for testing by NIH, which runs a donor program.

Another blood-sampling session is set for Tuesday night at the Adas Israel Congregation on Quebec Street NW. The blood tests are the first step toward determining a donor's suitability. Marrow extractions are done under local anesthesia in a hospital.

In a similar effort, just last month Gaithersburg neighbors of Craig and Connie Gordon helped locate more than 300 volunteers for blood testing and collected nearly $220,000 toward an anticipated bone marrow transplant for the Gordons' infant son Brian. Brian had been diagnosed as having metachromatic leukodystrophy, a fatal nervous system disorder.

However, the Gordons later learned that the transplant probably

an for the Life-Savers Foundation of America, a California-based organization that helps search for donors, are being held in escrow, with plans to be used for other victims.

For Atlas, there is little chance of reprieve without the transplant.

Increasingly weakened, struck by dizziness and blurred vision, she said she finds it hard to use stairs, and spends more than half her time in bed.

"I can't do a lot," she said.

All potential donors are, being solicited in the drive, regardless of ethnic origin, because their names can be entered on a national bone marrow registry used to aid victims of leukemia and other blood-related cancers, the blood drive organizers said.

In four years, the registry has signed up 58,000 people. But testing all those volunteers typically costs $300 per test by medical laboratories, though some have agreed to reduce the fee to $75 in cases of mass appeals. Those medical plans that pay for testing will do so only when family members are involved, Brown said.

The Atlas family and their friends, who face the cost of testing for many potential donors, are asking for contributions of money as well as blood. Donations may be sent to Life-Savers, care of Friends of Allison, 8314 Meadowlark Lane, Bethesda, Md. 20817.

will not be needed and all the money except that from one contributor

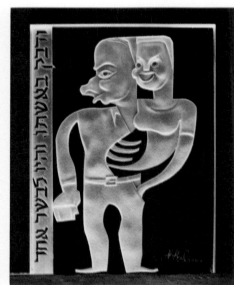

Adam's Rib
(Herman and Sara Perlman)

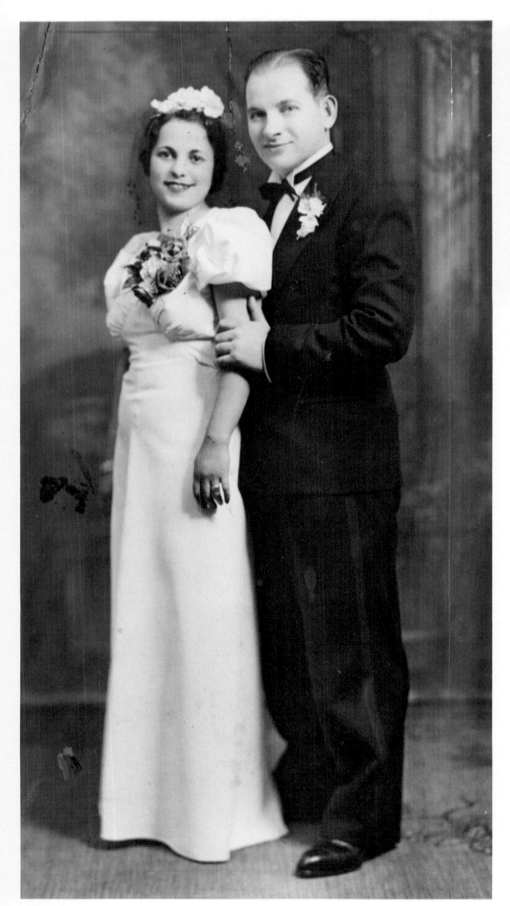

Sara Shuster, Herman Perlman
December 2, 1931

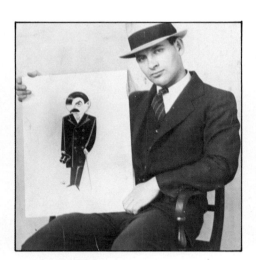

Herman Perlman, 1931
The caricature is of Pierre Laval,
Prime Minister of France, who was
visiting President Hoover in Washington.

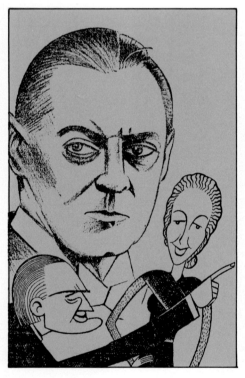

Lionel Barrymore as Senator Keane in
"Washington Masquerade."

In 1933, Perlman was again working at the *Post*. When Walt Disney visited the paper in order to sell his Mickey Mouse cartoon, Herman was instrumental in getting Disney his first appointment with the editor. Disney involved Perlman in a publicity campaign to promote the new cartoon. Children from all over the Washington area were invited to draw Mickey Mouse and Herman judged the entries.

Disney invited Perlman to come to work at his Hollywood studio, and in 1933 the Perlman family moved to California. Unfortunately, work at the Disney studio was not very stimulating. Perlman drew the "in-betweens," the series of pictures which, frame by frame, depicted characters moving from one position to another. After eighteen months working in this uncreative way, Perlman decided to go back to the east coast.

Instead of returning to Washington, Perlman went to New York City. His father was living there, and Herman had many contacts in the entertainment industry, through the management of RKO Keiths. His caricatures had been exhibited at the Keith theatre in Washington, and the manager of the New York office had invited Herman to come to the city to do a series of drawings of RKO stars. He was able to complete only twenty-five or thirty of the one hundred drawings specified in his contract: the manager lost his job, and Perlman's work was discontinued.

For a few months Perlman worked for Max Fleischer, creator of Popeye, whose New York studio was very like Disney's. Again the work was repetitive and he quit in order to work for an advertising agency, designing subway cards and platform posters. He might have stayed in New York, but his mother became ill in Washington, and Sara was expecting a second child. Herman decided to return to Washington.

He went to work for the Belasco Theatre on Lafayette Park, designing large posters for foreign films. When a position became available in the advertising department of the *Post*, Herman took it, with an agreement that for his caricatures he would be paid a weekly supplement of $45.00.

The Washington Post was now owned by Eugene Meyer, who recognized Perlman's talents and gave him a new and challenging assignment. Herman was to draw newly elected legislators, for a feature called "New Faces in Congress." Three times a week for three years, a Perlman caricature appeared with a short biography of the featured congressman.

Perlman's work was very well known in Washington, and in 1937 he and a copywriter friend opened the "Animated Cartoon School." Impressive space was rented in the penthouse of the Albee building. Herman designed special desks for the school, with glass panels on top. Light from below enabled the students to see the many tracings of their cartoons.

A dozen students enrolled for the ten-month course. Some of them were sent by the government, which was interested in using animation for training and information films. Perlman hoped to develop a group of animators who would be able to produce lengthy cartoons like those being done in Hollywood and New York. He had many ideas, one of which would feature the young George Washington as a cartoon character. He was also preparing an animated movie about a little girl tourist, "Alice in Washington."

However, not enough students could be enrolled to make a success of the school. In May, 1938 it closed, a victim of the depression and the fact that animated cartooning was not well known in Washington.

Later that year, reduced advertising revenues forced the *Post* to make drastic cuts in the staff, and Perlman was again laid off. He decided to return to New York, to his many contacts in the commercial art world. Here he was given the opportunity to establish another cartoon school.

A business-man named Mondell, who already had an established engineering school, offered to finance a school of animation if Perlman would organize it. Herman was very enthusiastic; surely in New York City such a school would be a success. State law required that the administrator of a school be a college graduate. Perlman went to Albany to argue that, even though he was a high-school dropout, his experience uniquely qualified him to operate a cartooning academy. The exception was made. He was granted a license, and in June 1939 the Mondell Institute of Art opened its doors.

Unfortunately, very few students applied, and most of them could not afford the tuition. The school was not a success, and Herman took his family back to Washington before the end of the year.

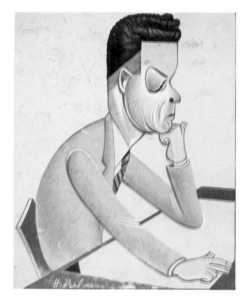

Lyle Boren of Oklahoma

Congressman seated at desk. Name unknown.

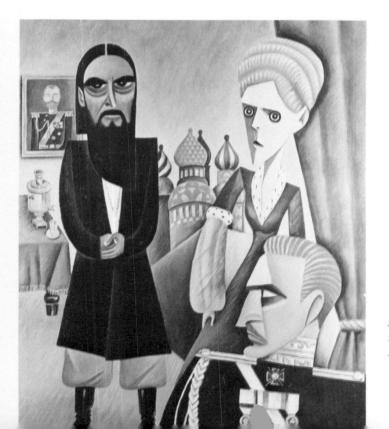

"Rasputin and the Empress"
This oil painting was commissioned by MGM as part of the publicity for the movie, which starred the three Barrymores.

The depression continued to make it a very difficult time for job-seekers, and in 1940 Perlman could not find enough work as a free-lance artist to support his family. In desperation, he accepted the help of a friend who was in the wholesale grocery business, and himself became a grocer. For five years, which Perlman later referred to as his "years of slavery," he and Sara worked long hours at the Perl Food Store. These were the years of World War II, and business was very good; but Perlman had no desire to remain a storekeeper. Soon after the war ended, he sold the business and went to Argentina to visit relatives.

Upon his return from South America, Perlman began to do a bit of art work, using space in the photo-engraving studio of his friend Nathan Peck. His first major effort was *Animated Cartooning*, published in 1946. This book was devised to serve as a self-teaching substitute for the type of course which Perlman had developed in 1937. However, he soon gave up animation and began to work exclusively as a designer.

There was a building boom in Washington. Public buildings, synagogues and churches, office buildings and schools, were being constructed in a wave of expansion which made up for the lack of activity during the depression and the war. Perlman began to work with architects and builders, designing details for both interior and exterior work. He worked on several synagogue buildings, designing the Ark and the Bima area with details such as Hebrew letters, tablets for the Ten Commandments, symbolic pairs of lions and memorial walls.

Two pages from Animated Cartooning, *1946. A how-to-do-it book published by Perlman for the novice animator. Perlman had developed his teaching methods while directing two schools of animation.*

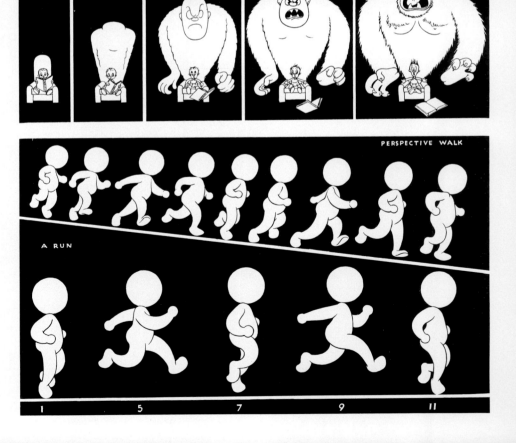

In 1949 Perlman embarked on a major change in his work. His friend Peck introduced him to Willis Lowry, an artist who carved glass, using a sandblasting technique. Perlman was fascinated by the varying effects of the sand on the clear glass. Lowry used equipment of the most primitive type, and Perlman saw immediately that with improvement, the machinery could be used more safely, effectively and efficiently. Lowry, a Seventh Day Adventist, was about to leave for missionary work in India. He sold his shop and equipment to Perlman.

At that time, Perlman was designing the Holy Ark for B'nai Israel's new synagogue on 16th Street. He included his first glass designs, symbols of the twelve tribes of Israel.

This was the beginning of Herman Perlman's experience with glass. Drawing upon his knowledge of air-brush technique and his expertize as an electrician, Perlman spent much of the next several years improving the equipment. At the same time, he developed his skills so that he was able to go beyond simple frosting and become expert in carving dramatic pictorial effects. In the meantime, he produced a full spectrum of glass-frosted items, from hotels and bank signs to decorative cocktail table tops.

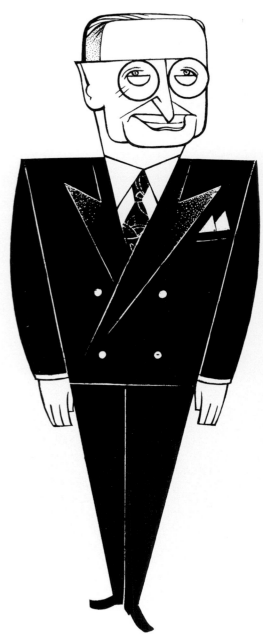

Harry Truman, President of the United States, 1950

His work in the White House brought a great deal of publicity to Perlman. During the Truman administration, the White House was undergoing extensive restoration. Perlman was commissioned to make glass panels for five bathrooms. For the partition next to the President's bathtub, Perlman carved a bald eagle holding an olive branch. At the bottom of the panel, in an area which would be sealed against the wall, Perlman engraved a special message of his own composition — *"In this tub bathes the man whose heart is clean and who serves the people faithfully."* In 1952, he won first prize on nationwide television by telling the story of his secret White House message on Gary Moore's popular program, "I've Got a Secret."

Perlman became known for his glass murals, and he received commissions for work on banks, restaurants and private homes as well as in public buildings and religious institutions. For the Rive Gauche restaurant, he etched scenes of France; for the Investment Building Cafeteria he did Washington landmarks. For the Sacred Heart Church in La Plata, Maryland, he etched a large medallion for the glass wall leading to the sanctuary. For the Madison National Bank, he etched a round seal for the window, with the image of James Madison in the center. In Fredericksburg, Virginia, Perlman designed twelve door panels for the Mary Washington Hospital. Each panel depicted a scene from the life of George Washington's mother.

Working on panels for the Truman White House. 1952. Perlman removes tape from the areas to be sandblasted.

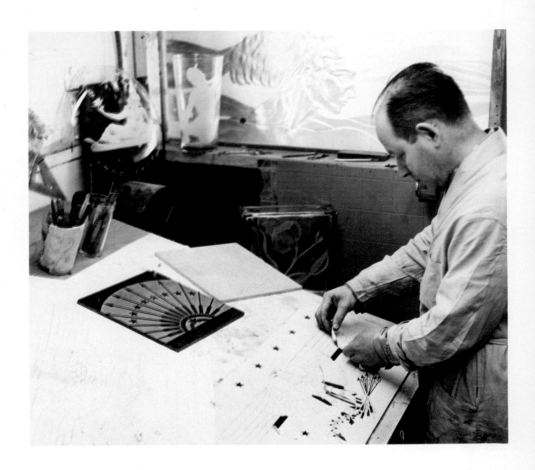

Hooded to protect himself from the spray of abrasive sand, Perlman directs his nozzle at the areas of the design which are exposed for carving.

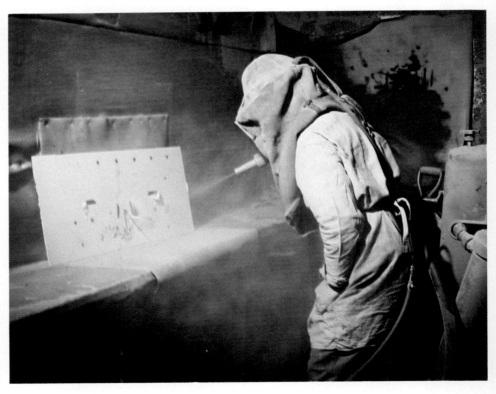

For twenty-six years, Perlman was assisted by George Morgan, who became a master at shaping and polishing the pieces of glass. He performed many of the tasks which supported Perlman's carving. Until his death in 1978, Morgan was Perlman's right hand, proudly accompanying his employer to several exhibitions and even creating some of his own work, in an abstract style.

The largest commission which Perlman did was the Virginia War Memorial in Richmond. On a glass wall 110′ wide and 30′ high, and on marble columns, Perlman engraved 11,000 names, the casualties of Virginia from World War II and the Korean War. Perlman worked for a full year and used six helpers to complete this monumental project, in which each name was engraved in letters 1⅜″ high.

In spite of Perlman's role as one of the most important artisans for this memorial, he was not given permission to sign the work when it was completed in 1955. Twenty-five years later, he wrote to Virginia's Governor John Dalton asking that his name be affixed to one of the panels. It was with great satisfaction that Perlman visited the site in 1981 and viewed a newly engraved inscription which read, "Glass sculptor—Herman Perlman."

The United States Park Service commissioned Perlman to create a large wall of glass for the Abraham Lincoln Historical Park in Hodgenville, Kentucky, where the sixteenth president was born. Perlman engraved a six-foot tall figure of Lincoln with his head bowed and his hands clasped in front of his coat. The window also contains the texts of several quotations.

In 1961, Perlman received recognition from the Washington Building Congress for the glass medallions which he made for the Riggs National Bank. The next year, he was honored again, for his work on the Howard University Fine Arts Auditorium. Perlman had done a large panel in which symbols of art, music and drama are combined. Until its destruction during a student protest, it could be seen at the main entrance of the auditorium. Another mural was made for the lobby of the Home Economics Building at Howard, where Perlman designed a scene from black family life.

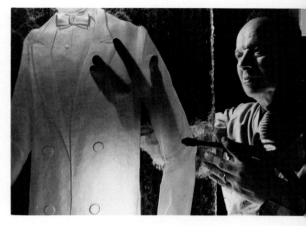

With glass taken from the dome of the U.S. Capitol, Perlman carved a figure of Abraham Lincoln. (Lincoln University, Oxford, Pennsylvania)

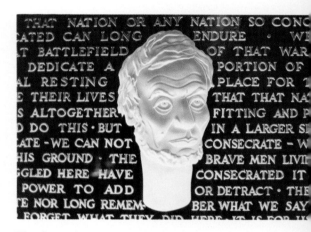

The Gettysburg Address (A detail from the piece in the collection of the B'nai B'rith Klutznick Museum, Washington, D.C.)

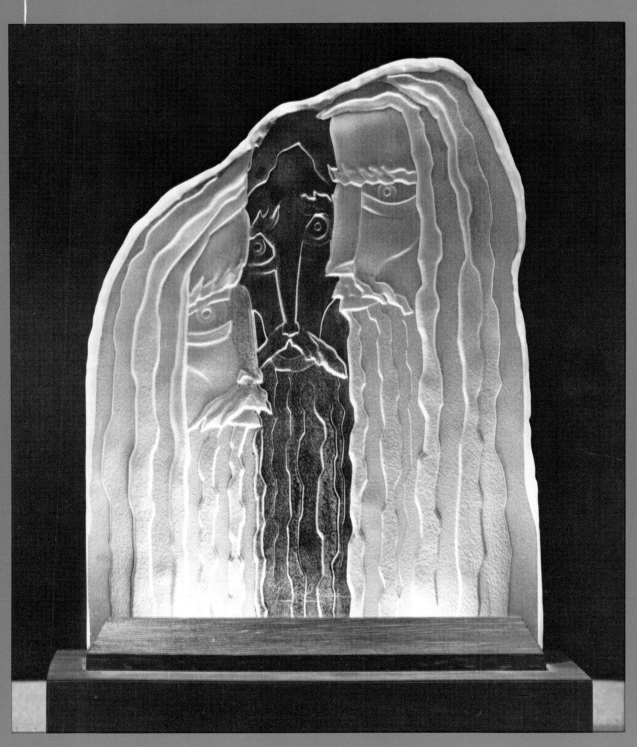

The Patriarchs: Abraham, Isaac and Jacob

During the late 1950's Perlman began to experiment with Biblical themes, trying to express the reverence and joy in his Jewish heritage which was so much a part of his personal life. For several years he was dissatisfied with the results of these works, but he persisted and was able to develop a style of basrelief in which the sinuous line and sparse modelling were perfectly suited to the medium of glass and to the religious fervor which he wanted to communicate. Always a perfectionist, Perlman decided to destroy the early examples of this work. He buried them beneath the new paving of his driveway.

In 1962, Perlman's life and work took a new direction, leading him into the world of fine art, with all that goes with it—exhibitions, speeches, collectors, travel, and pressure to produce.

It happened very strangely. A truck delivered a large panel of glass to Perlman's studio. The driver explained that a lady would call to order what was to be done with it. But she never called. For a year, the glass waited in the studio. Perlman advertised in the newspapers, but no one claimed it. Finally he unwrapped the panel, and was overwhelmed to see a flawless piece of one-inch glass. It was thicker than the glass he usually used, and it had a jewel-like quality which inspired him to use it for the religious sculptures that he was confident he could now execute to his own satisfaction.

In later years, Perlman would often refer to the mysterious woman of the glass panel as a "guardian angel," and he felt that the glass was a gift from God. Recalling the moment when he first unwrapped the glass, he said that "Biblical personalities seemed to develop before my eyes." He cut the panel into eighteen pieces, of varied sizes and shapes, and began to translate his visions into translucent shadows in the glass.

Because this glass was thicker than usual, Perlman was able to carve more deeply than ever before; and his figures took on a three-dimensional character which he had not achieved in earlier work. The pieces included images from the Bible, portraits from modern Jewish history, and a figure of Abraham Lincoln. Perlman fully intended to keep the sculptures for himself. However, they were not destined for obscurity. Rabbi Norman Gerstenfeld was in the studio inspecting a memorial wall which Perlman was completing for the Washington Hebrew Congregation. Overcome with admiration for the images which he saw before him, Rabbi Gerstenfeld urged that the glass sculptures be exhibited; and he invited Perlman to have his first show in the synagogue library.

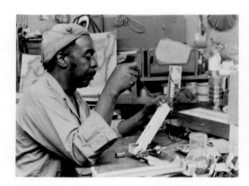

George Morgan, Perlman's assistant, wires a sculpture base.

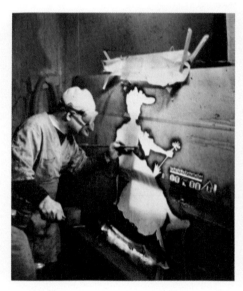

Perlman working on the Hahn Shoe Store mural. 1960.

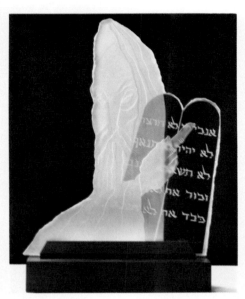

Moses

The library was a dimly-lit room, panelled in dark wood. Perlman mounted each of his works on a wooden stand containing a small fluorescent light. The effect of this "edge-lighting" was very dramatic. Coming from below, the light seemed to originate in the glass itself, highlighting the forms which were carved into the back and giving them a three-dimensional quality.

The exhibition was a success. *The Washington Post* art critic, Leslie Judd Ahlander, encouraged Perlman to do more work, so that there would be enough pieces for a more substantial exhibition. An official of the National Housing Center invited him to show the work under the sponsorship of the nation's glass manufacturers. Robert Shosteck, of the B'nai B'rith Klutznick Museum, offered to exhibit Perlman's works as soon as more were ready. And Shosteck suggested that he do additional portraits of important Jews, both historical and contemporary.

In addition, Perlman was besieged by strangers and friends who wished to purchase his work. He was reluctant to part with any of the sculptures, but he began to accept commissions to duplicate the original pieces, and he varied his representation of some of the thematic material so that during the 60's and 70's he produced a large body of work.

One exhibition led to another. Soon Perlman and his beloved Sara were travelling all over the country, to attend the opening ceremonies of exhibits in synagogues and Jewish Community Centers in Houston, Los Angeles, Baltimore, Cleveland, Chicago, Phoenix, Memphis and many more cities. In 1966 he returned to Columbus, Ohio, where many relatives and childhood friends attended his exhibition. Wherever his work was shown, the pieces were purchased by people who were captivated by the brilliance of the glass and the frosty textures and rhythmic outlines of the figures.

Perlman received many commissions to make presentation pieces. From the Big Brothers, columnist Drew Pearson received a Perlman sculpture of a man and boy going fishing. The Pittsburgh Plate Glass Company asked Perlman to carve the state bird of Pennsylvania, a ruffled grouse, for presentation to Governor Milton Shapp. Astronaut Jim Irwin received a sculpture in which Perlman depicted the implanting of the American flag on the surface of the moon.

From the time of his first exhibit at B'nai B'rith headquarters in Washington, in 1964, Perlman had a very special relationship with the organization. He was invited to show his work at several conventions; his pieces were given by B'nai B'rith to Israeli diplomats who served in the United States; local lodges of B'nai B'rith purchased his work when a presentation piece was needed. One of his outstanding commissions was from the Justice Lodge in Philadelphia, which presented a yearly award to an important juror. Perlman made several of these presentation pieces, including works for Supreme Court Justices William O. Douglas and Tom C. Clark.

In 1972, B'nai B'rith sponsored a first day stamp issue honoring the Peace Corps. It was issued on an envelope which bore a photograph of Perlman's dove of peace, the "Shalom" image, always a favorite sculpture among collectors and donors of Herman's work.

In Jerusalem at the 1974 B'nai B'rith convention, Golda Meir, Prime Minister of The State of Israel, was presented with her own portrait in glass. Herman and Sara Perlman travelled to Israel in order to participate in the ceremonies. Mrs. Meir signed her own name in the glass, using Perlman's diamond-tipped stylus.

During the mid-70's, Perlman created two pieces for the most important of B'nai B'rith's annual presentations. The first, in which a hand holds a seven-branched menorah, is surrounded by a text from *Sayings of the Fathers*, "The world is sustained by three things—Torah, worship and loving deeds." This image was awarded several times, to Senator Jacob Javits, comedian Danny Kaye, Vice President Walter Mondale, philanthropist Philip Klutznick and others. A second image, of a mother and two children, was designed for B'nai B'rith Women and given to soprano Beverly Sills, among others.

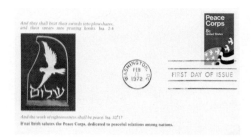

First day stamp issue honoring the Peace Corps and featuring Perlman's Shalom (Peace) sculpture. 1972.

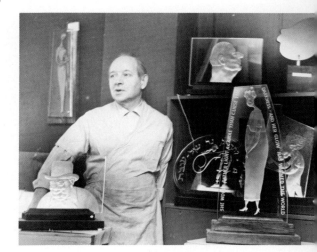

Perlman in his studio, 1965. Caricatures and portraits include Winston Churchill, Charles de Gaulle, Eleanor Roosevelt and Albert Einstein.

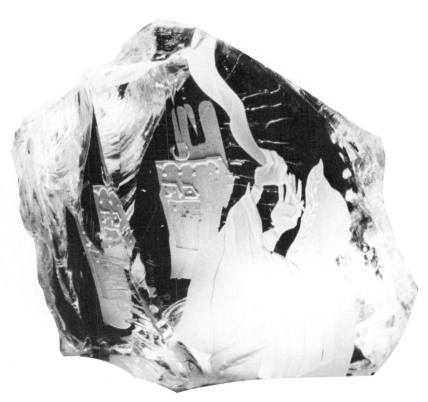

Blowing the Shofar

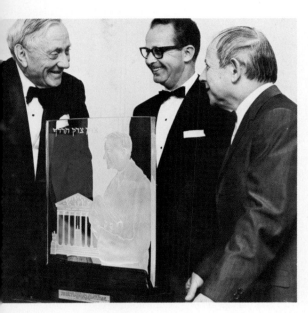

Justice William O. Douglas (left), artist Perlman (right), as Douglas receives the B'nai B'rith Humanitarian Award in Philadelphia. Hebrew inscription reads, "Justice, Justice Shall Thou Pursue."

A s his work became familiar to religious and lay leaders all over the nation, Perlman received commissions for large religious works. For the United Orthodox Synagogue in Houston, he designed a Holocaust Memorial Wall. For the youth wing at Temple Beth Sholom in Elkins Park, Pennsylvania, he executed a Noah's Ark and a scene of children and their teacher. The latter included the text from Isaiah 54:13, "And all thy children shall be taught of the Lord…"

Perlman continued to serve Washington architects as the prime craftsman in glass. In 1972, he fashioned the large doors and transom for the entrance of the Renwick Gallery, which was being restored to its original appearance. In keeping with the Victorian origin of the building, Perlman's glass panels are frosted with a handsome medallion motif. Next door to the Renwick, the historic Blair House was also being restored. For that building, Perlman designed frosted glass panels for eight interior doorways.

Even as he entered the eighth decade of his life, commissions kept Perlman busy. At the entrance of the new Federal Reserve Board building, he designed two large eagles, for which he received another award from the Washington Building Congress, in 1976. For St. Thomas Moore Church in Arlington, Virginia, Perlman made a large window depicting the Baptism of Christ.

His major efforts, however, were still directed toward thematic material from his Jewish heritage. For Adath Israel in Cincinnati, Ohio, he installed a fifty-foot long wall illustrating the twelve tribes of Israel. He designed a series of twenty panels for the glass-enclosed walkway which connects the two buildings of Temple Oheb Shalom in Baltimore, illustrating the Jewish holidays and the tribes of Israel.

At Walter Reed Hospital in Washington, D.C., Perlman designed a Holy Ark for the chapel. Major works were also installed at Ohr Kodesh Congregation in Chevy Chase, Maryland, Beth Sholom Synagogue in Washington, D.C., the Arlington Jewish Center in Virginia and the Hebrew Home for the Aged in Rockville, Maryland.

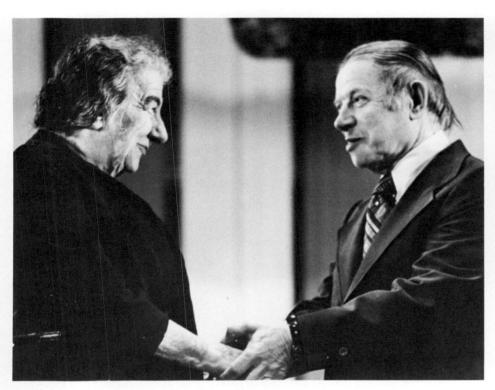

*Prime Minister of Israel Golda Meir
greets Herman Perlman. 1974.*

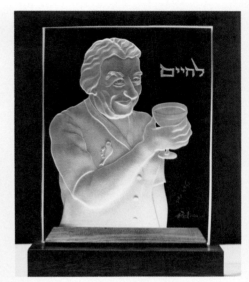

Golda Meir: L'Chayim (To Life)

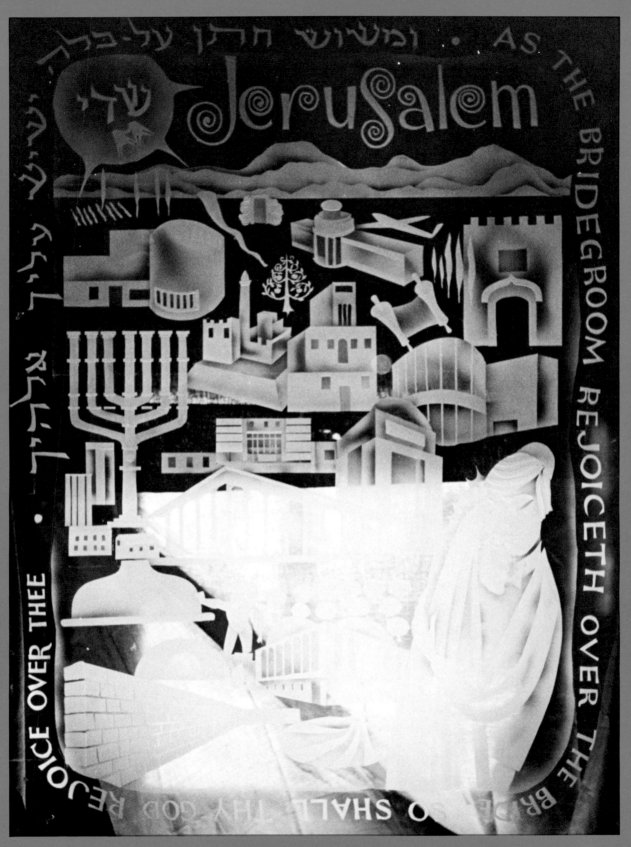

Jerusalem Window
This six-foot tall window, poorly photo-
graphed at Perlman's studio, was later
installed at the B'nai B'rith Klutznick
Museum, Washington, D.C.

The tragic death of Sara Perlman in 1979 almost brought Herman to abandon his work. He had nursed her with great dedication throughout her long illness, and was deeply affected by the loss of his companion of forty-eight years. In his depression, Perlman felt that he did not want to continue working. Beginning in 1977, he cancelled many exhibitions and refused most commissions.

It was the preparation of a permanent memorial to Sara which brought Perlman back to his work. Anxious to honor his wife's memory, Perlman offered a selection of his sculptures to the B'nai B'rith Klutznick Museum. These included a magnificent Jerusalem window, two Lincoln portraits and several pieces which highlight the Jewish experience. They were installed in a gallery which is dedicated to Sara's memory and is known as the "Herman and Sara Perlman Crystal Room."

Gradually, Perlman resumed his work, although at a reduced pace. He accepted invitations to exhibit work, in Hartford, Baltimore, Dayton and other cities, but much of his pleasure was diminished without Sara at his side. His children and grandchildren were very supportive, going with him on vacation trips as well as to his exhibitions. He began to depend on his son Marvin, an engineer, to help part-time with studio work and anything in which an extra pair of hands was needed.

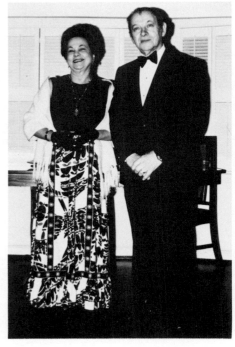

Herman and Sara Perlman, 1976

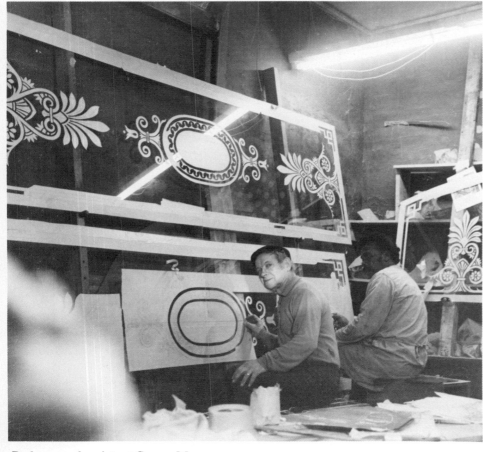

Perlman and assistant George Morgan work on the doors of the Renwick Gallery, Washington, D.C. 1972

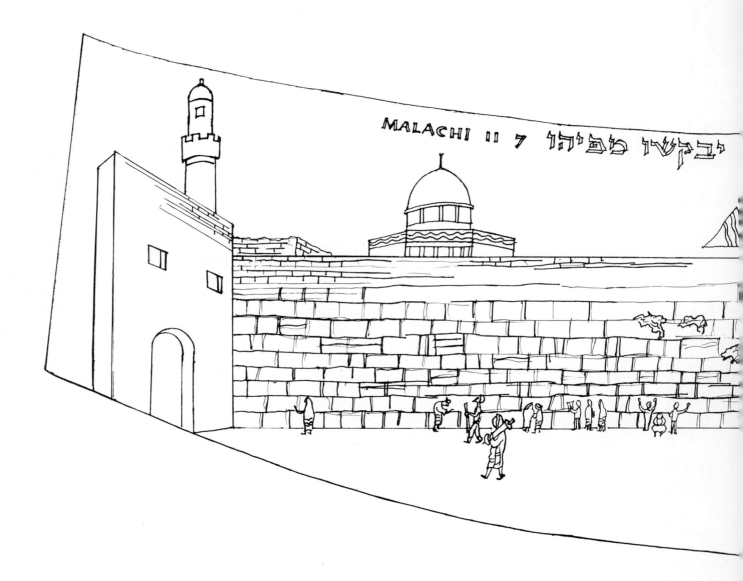

MALACHI II 7 וְתוֹרָה יְבַקְשׁוּ

Perlman's preparatory drawing for the glass wall, "Images of Jerusalem," at Adath Israel in Cincinnati. The text is from Malachi 2:7, "The lips of the priest shall preserve knowledge and you shall seek Torah from his mouth."

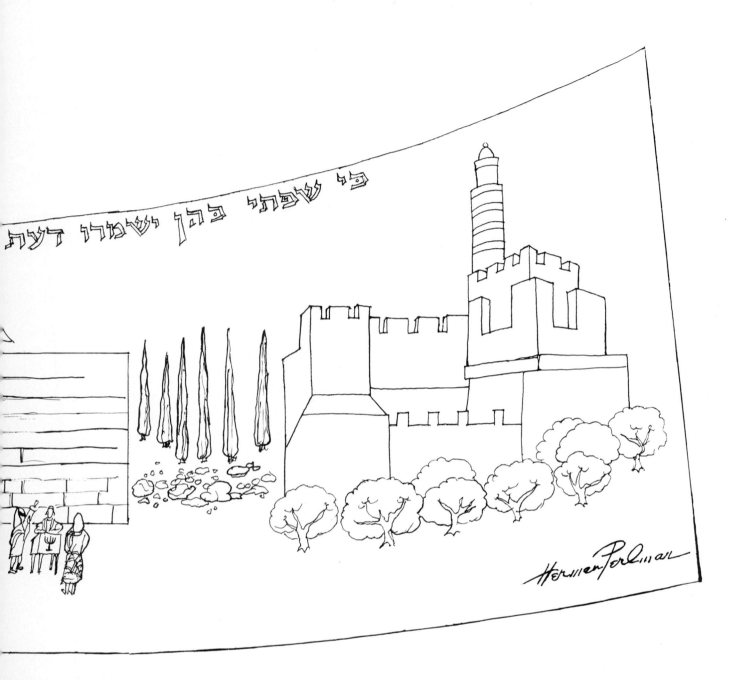

At the urging of his family, Perlman participated in the preparation of this book, in order to record the story of his life and work. He also began to prepare a series of drawings, anticipating the time when he might not be strong enough to work on heavy pieces of glass. But for the present, he continued to work in his chosen medium. He completed several panels of the Jewish holidays for the memorial hall at Agudath Achim Congregation in Alexandria, Virginia and more than a score of individual sculptures commissioned by collectors. His largest work in 1981 was a Jerusalem window for Adath Israel in Cincinnati, Ohio. In order to complete this window, he worked on site, in rain and fifty-degree temperatures, filling the ten foot long glass panel with scenes of the "City of Gold."

At the age of seventy-seven, he was still carving images in bright spaces.

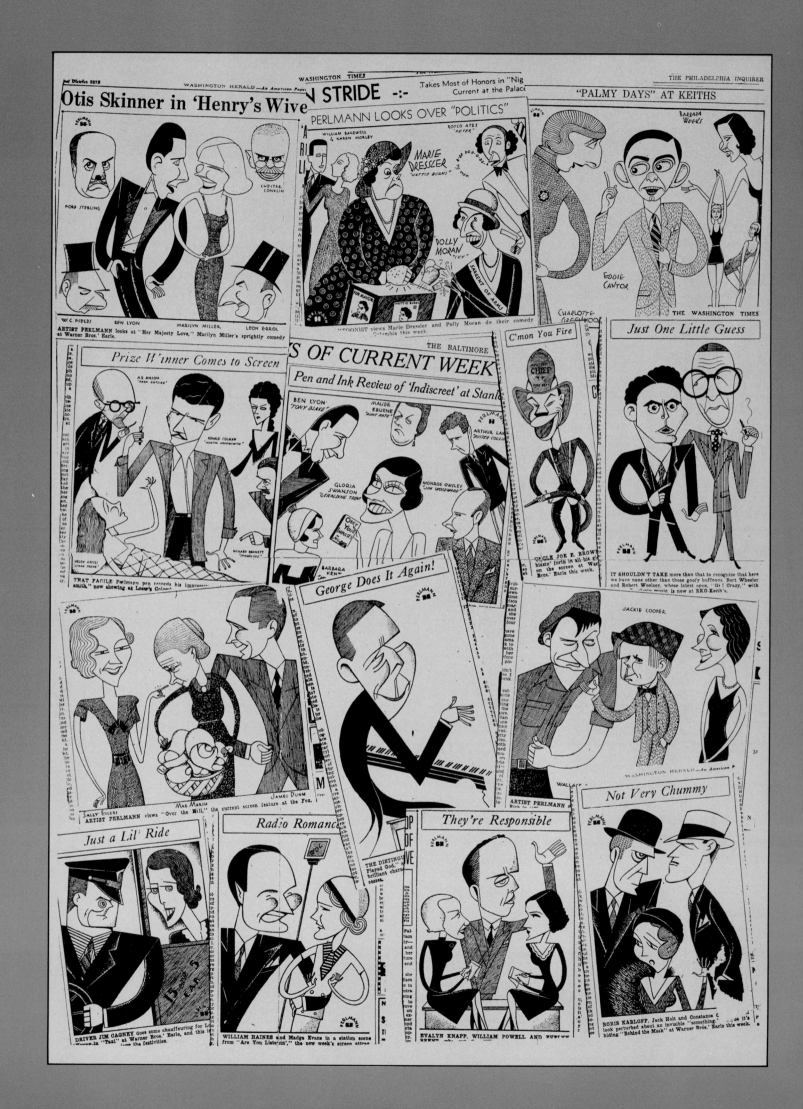

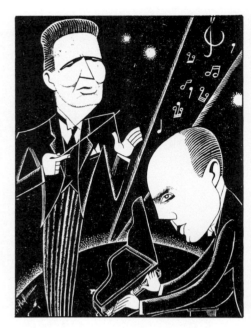

Perlman's collection of caricatures from the 1930's is the earliest of his work which is still in existence. Clipped from the newspapers, these figures from the past have a timeless quality which belies the brittle newsprint, browned with age, on which they are printed. The faces are clearly recognizable; an emphasis on geometric forms gives them a classic simplicity. Perlman's confident use of simple lines and shapes and his ability to exaggerate the physical characteristics of his subjects while maintaining the integrity of each person's appearance, made him a favorite among Washington illustrators.

He varied his technique and even his signature, in order to distinguish the different aspects of his work in caricature. The theatrical caricatures have a one-dimensional character; no shaded areas are included to push the figures beyond the flat plane of the paper. Instead, selected areas are varied with a mixed vocabulary of textures which includes hatchings, dashes, squiggles and solid tones.

Bruno Walter, Conductor and Walter Gieseking, Pianist

For many of these theatrical caricatures, done as part of his free-lance work, Perlman added an extra N to his name and created a logo in which the H for Herman sits under an umbrella of letters which form the name "Perlmann." A simple signature, H. Perlman, identifies the creator of the series, "New Faces in Congress." These drawings were very different from his theatrical and movie work. They were printed in halftone to reproduce his originals, which had been done in opaque watercolor. The figures in this series were modelled with a slight feeling of three-dimensionality which gives weight to each character.

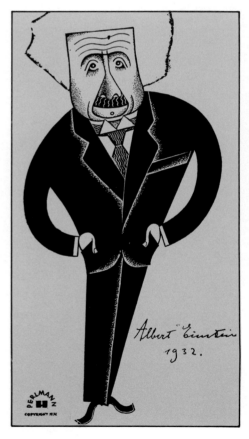

On several occasions, Perlman's free-lance work gave him the opportunity to go beyond black and white illustration and create a painted composition. Actors Wallace Beery and Frederic March were portrayed on their respective stages, costumed and surrounded with details which identify their roles as Pancho Villa and Benvenuto Cellini. His painting of the Barrymores, done for the movie "Rasputin and the Empress," is the most complex of these, with three figures on the stage. Perlman was perfectly at home in the medium of oil paint. The surface is smooth, with gradual transitions from light to dark giving the effect of three-dimensionality. The strong colors highlight the modelling of the figures and the exotic look of the Russian architecture.

A sheet of Perlman caricatures, used in a brochure which advertised Perlman's work to theatre owners.

Albert Einstein

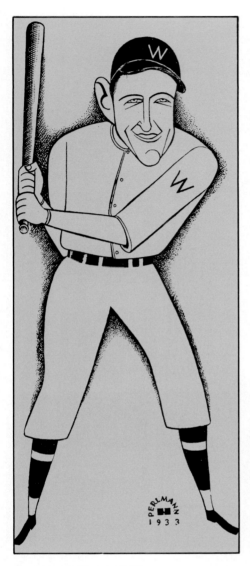

Joe Cronin, Baseball Player

Perlman's book on animated cartooning methods explains the techniques of animation in series of black and white illustrations which break down the action of the human or animal body into small steps. Perlman's puckish humor enlivens the how-to book, making it interesting not only for the apprentice animator, but also for the viewer of animated cartoons.

Occasionally, Perlman departed from his usual materials and techniques in order to give expression to a caricature. His three-dimensional metal sculpture of President John F. Kennedy reduces the figure to two instantly recognizable characteristics. Labelled "Press Conference," we know from the shape of the hair and the pointing finger that this is Kennedy.

A more complex assemblage is Perlman's composite portrait of Andrew Mellon. Wicked in its humor, the sculpture combines a portrait of Mellon with objects which symbolized his enormous investments in American industries, from a toy train to a light bulb, a dollar bill to a gas pump.

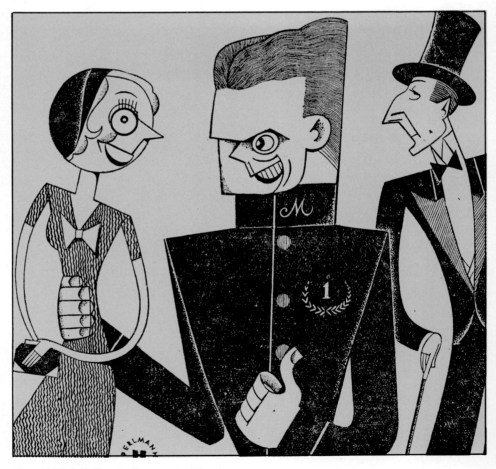

Joan Blondell, James Cagney and Louis Calhern in "Blonde Crazy."

Ralph Bellamy, Joan Bennett and Charles Farrell in "Wild Girl."

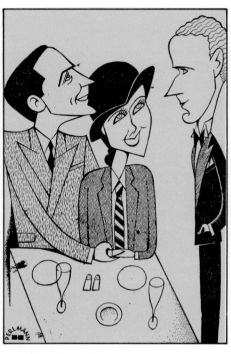

Frederic March, Norma Shearer and Leslie Howard in "Smilin' Through."

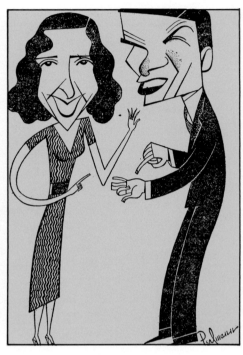

George Burns and Gracie Allen

"Bird in Hand" by John Drinkwater.

Miriam Hopkins and George Bancroft in "The World and the Flesh."

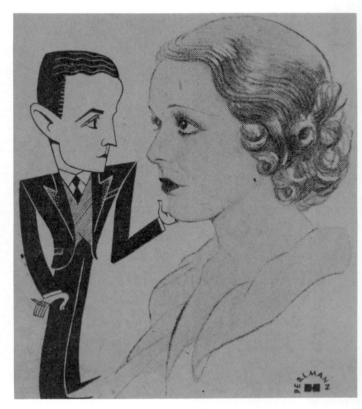

John Darrow and Sally Blane in "Forbidden Company."

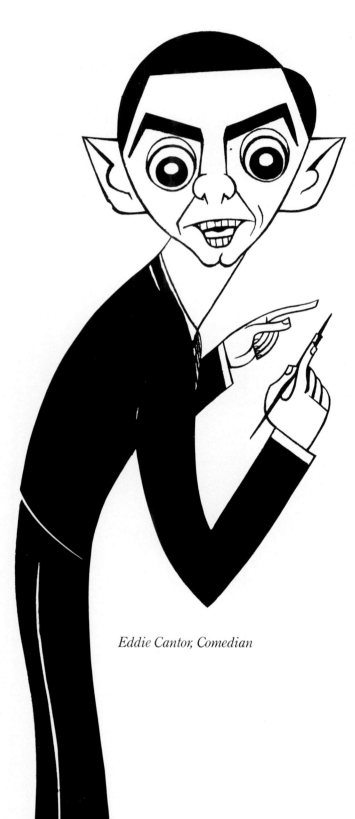

Eddie Cantor, Comedian

"Fatty" Arbuckle and Abe Lyman.

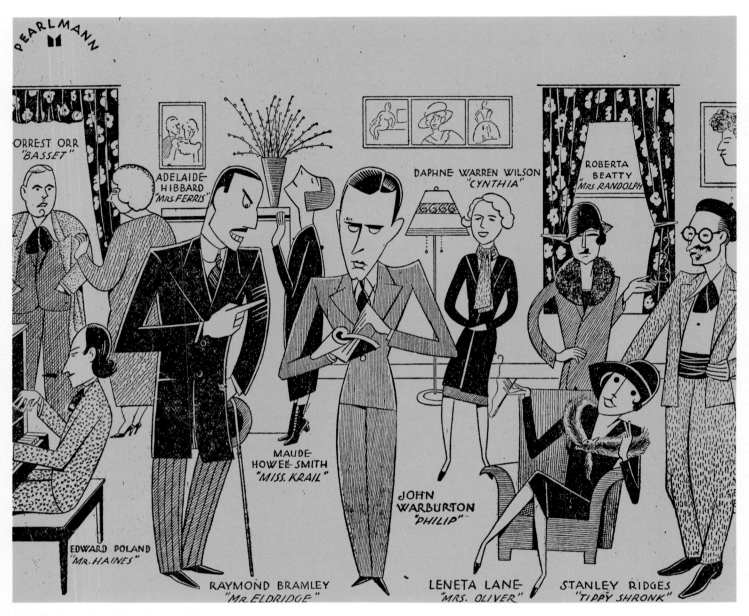

"Phillip Goes Forth" by George Kelly

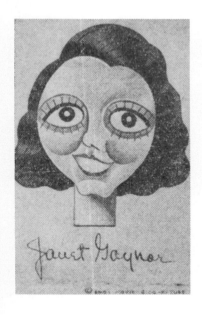

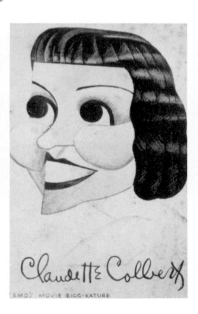

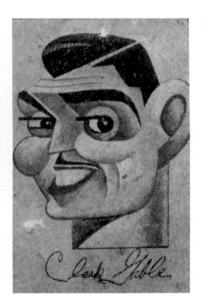

Far left: Janet Gaynor
Center: Claudette Colbert
Left: Clark Gable

45

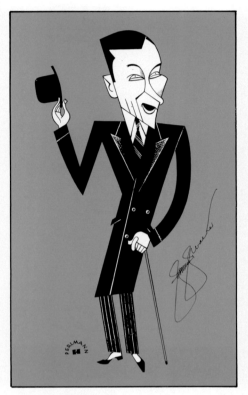

"Jimmie" Walker, Mayor of New York City

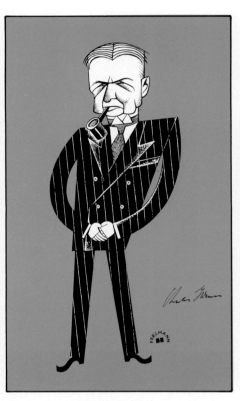

Charles G. Dawes, Vice President, 1925-1929

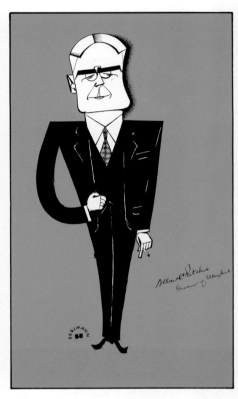

Albert C. Ritchie, Governor of Maryland

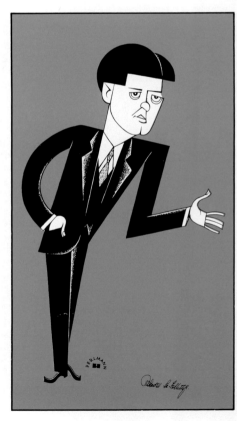

Senator Robert M. La Follette Jr.

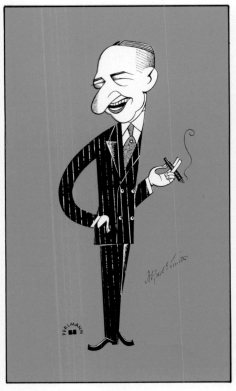

Alfred E. Smith, Mayor of New York City and Governor of New York State.

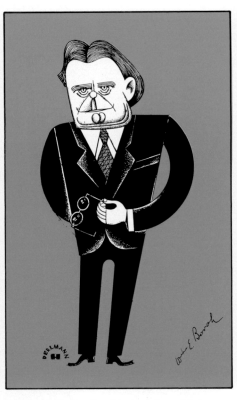

William E. Boroh, Senator from Idaho

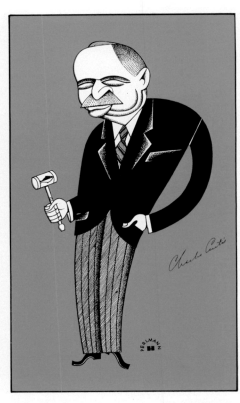

Charles Curtis, Vice President, 1929-1933

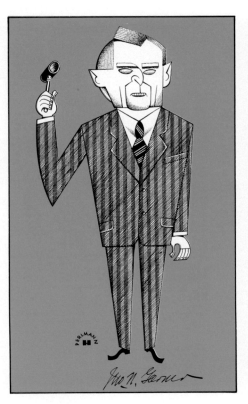

John Nance Garner, Vice President, 1933-1941

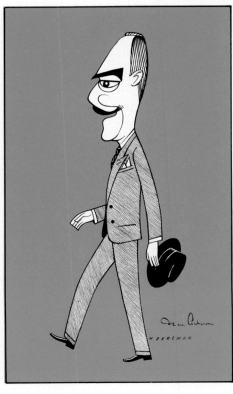

Dean Acheson, Secretary of State

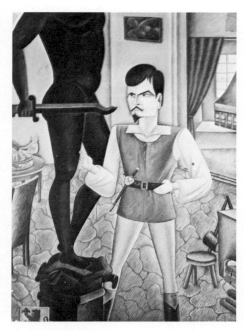

Frederic March as "Cellini," an oil painting done for MGM

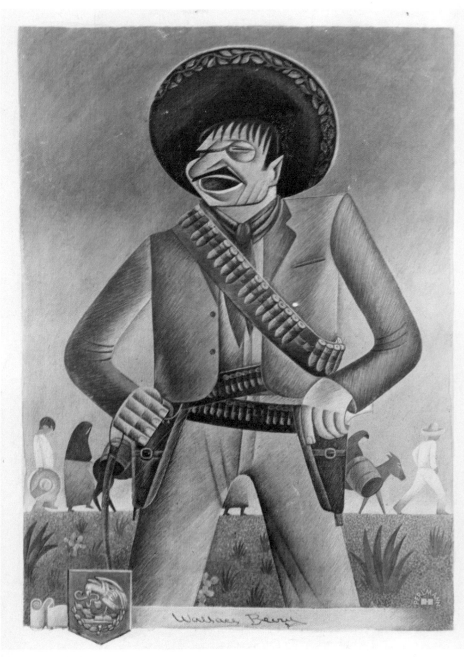

Wallace Beery as Pancho Villa (Oil painting in color)

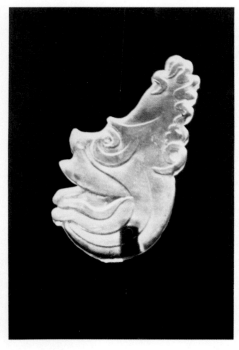

Senator Everett Dirksen

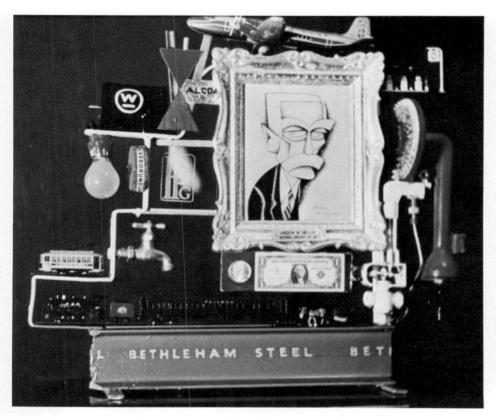

Andrew Mellon
(Assemblage)

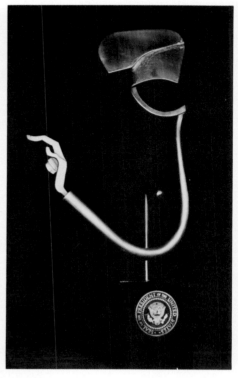

"Press Conference"
John F. Kennedy (Metal sculpture)

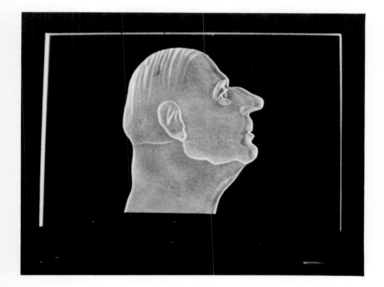

Charles de Gaulle of France

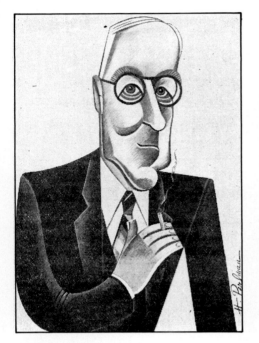

Fred J. Douglas

Harrington of Iowa

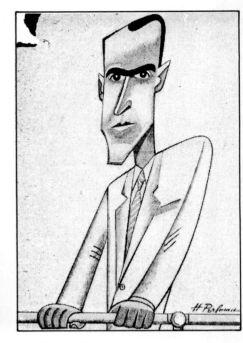

Dudley A. White

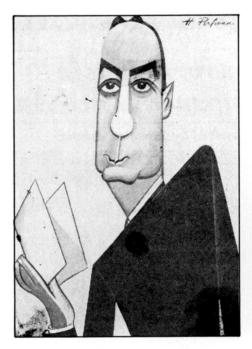

Peter J. Demuth

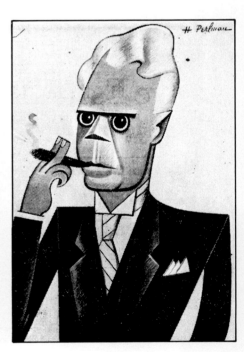

Joseph A. Dixon

Perlman caricatured newly elected Congressmen for a three times weekly feature in The Washington Post.

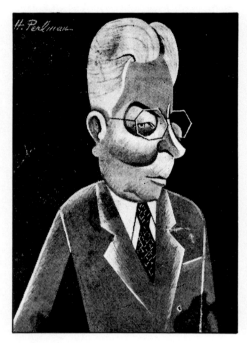

Clyde H. Smith

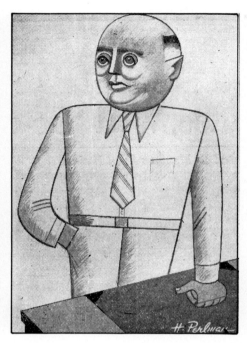

Harold K. Claypool

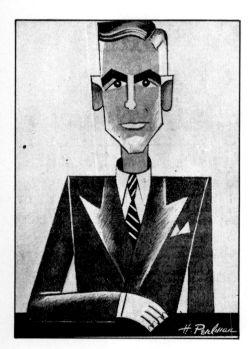

Congressman Izac

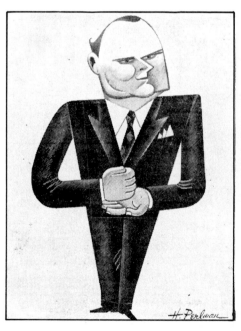

Clyde L. Garrett

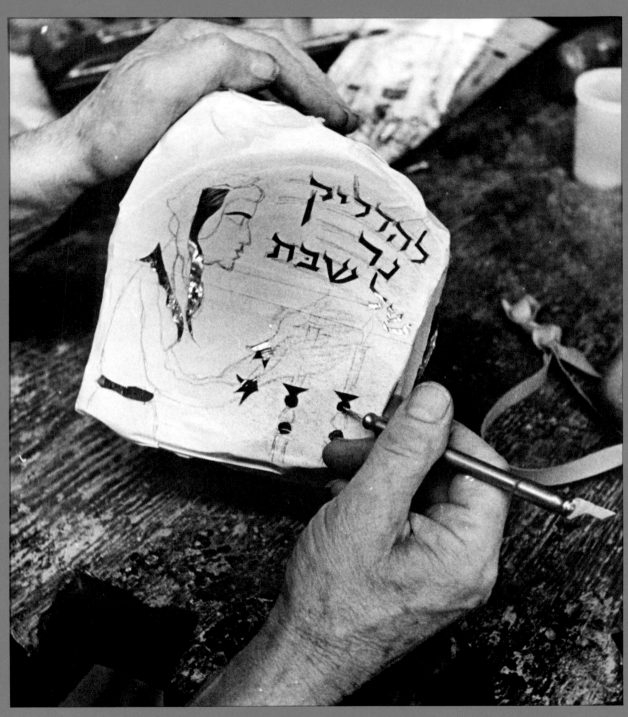

*He cuts the tape away from the surface
of a small chunk of glass, exposing the
places which are to be etched.*

Perlman developed his methods for etching into glass during the years following 1949, when he purchased the glass-carving equipment. He saw the possibilities for doing more than shallow frosting to make simple shapes or letters contrast with the sparkle of the clear glass. Perlman refined the machinery so that he could cut as deeply as one-quarter inch while maintaining very tight control over the area being etched.

In simple frosting, the glass loses its clarity when fine sand particles are sprayed against it under high pressure, much as a fire-hose sprays water. To etch lines of varying width into the glass, the sand must be forced through nozzles which vary in diameter. And to control the speed of the cutting, the pressure of the sand must be finely controlled. Finally, to preserve those areas of the glass which are not to be etched, the glass must be protected from the sand.

Perlman begins his work with a detailed pencil sketch on tracing paper. A slab or chunk of clear glass, which has been cut for the design, is covered with heavy masking tape and the sketch is transferred to the tape. Because Perlman usually works on the back of the glass, everything must be done as a mirror image, so that when the work is completed it will appear correctly from the front.

With a finely pointed knife, Perlman cuts away those portions of the tape which cover the areas to be etched and exposes the glass. The tape which remains is resistant to the abrasive sand and protects the unblemished surface of the glass. The areas which are to be etched most deeply are uncovered first. Most pieces are etched several times, with more of the design uncovered for each application of the pressurized sand.

To protect himself from the cloud of sand and dust which results from the ricocheting abrasive, Perlman works with the glass panel placed inside a cabinet. From the outside, he looks through a large window. Reaching in with rubber gloves, he holds the nozzle and starts the compressed air machinery. Controlling the pressure of sand and air, Perlman directs the spray against the glass, following the design which he has exposed by cutting away the tape.

When working on large pieces, Perlman cannot use his special box. Instead, he leans the glass against an easel and works in an open room. Dressed in a window-fronted hood to protect his head from the stream of abrasive bouncing off the glass, and holding his hose to the work at hand, Perlman gives the appearance of an astronaut working in a dimly-lit cave.

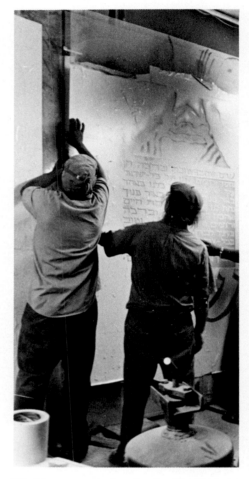

Working on a window for the Ohr Kodesh Synagogue in Chevy Chase, Maryland. 1977.

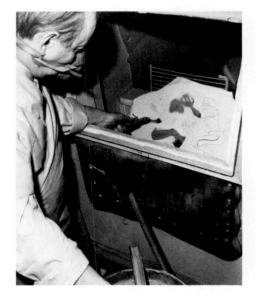

Perlman readies a glass sculpture for blasting in his cabinet.

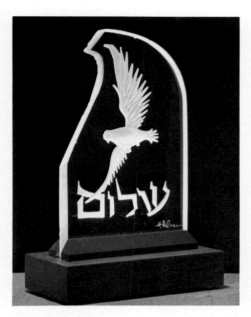

Shalom (Peace)

Perlman first worked with plate glass and window glass for ordinary jobs. For special work, he had a limited supply of German glass obtained from the Navy. It had been made for windows in wind tunnels used by German scientists; after World War II it was brought to Washington.

The large piece of glass which was left at his door in 1962 was of the finest quality, exactly what was needed for the sculptures to which he finally devoted his life. Perlman needed a polished flat glass fine enough to allow light to penetrate without any barriers caused by imperfections or variation in color or clarity.

For many years, Perlman used a product of the Pittsburgh Plate Glass Company. It was 3/4″ in thickness, and produced by a method which was discontinued by 1970. It then became difficult for Perlman to obtain glass. He purchased various imported and domestic varieties, but never found a totally satisfactory product at a reasonable price.

Just as the flat glass was no longer available, so also was the "cullet," or chunk glass which he first used in 1967. By 1980, Perlman had to discontinue his work on chunks. For many years, Perlman used small bricks of paving glass, inscribing them with names, in both Hebrew and English. By 1981, these also were discontinued by their manufacturer. Fortunately, Perlman has a fairly complete stock of glass still on hand in 1982. He hopes to use every piece.

Where does the light come from?

A small fluorescent bulb within the wooden base sends a wave of light through the glass. Coming from below, the light seems to originate in the glass itself, highlighting the forms which have been carved into the back and giving them a three-dimensional quality.

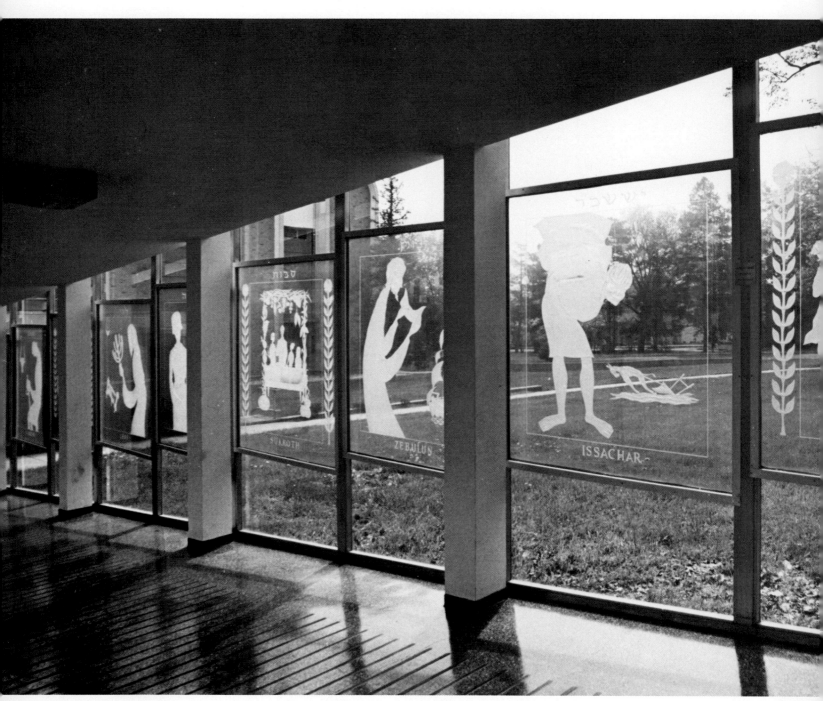

Temple Oheb Shalom,
Baltimore, Maryland
The twenty windows which Perlman
made for this glass-enclosed walkway are
illustrations of the twelve tribes of Israel
and eight major Jewish holidays. Each
panel is sixty inches square. Pictured here
is the south side of the walkway, which
contains ten of the panels.

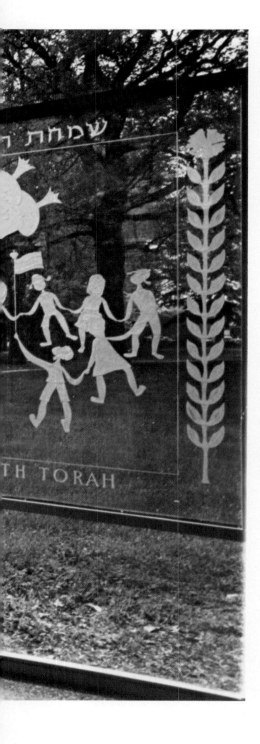

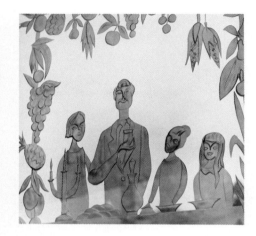

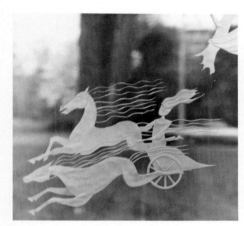

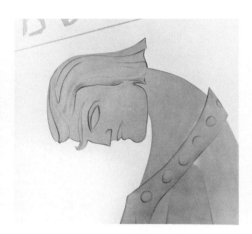

*This and the following page contain
details from the windows at Oheb Shalom.*

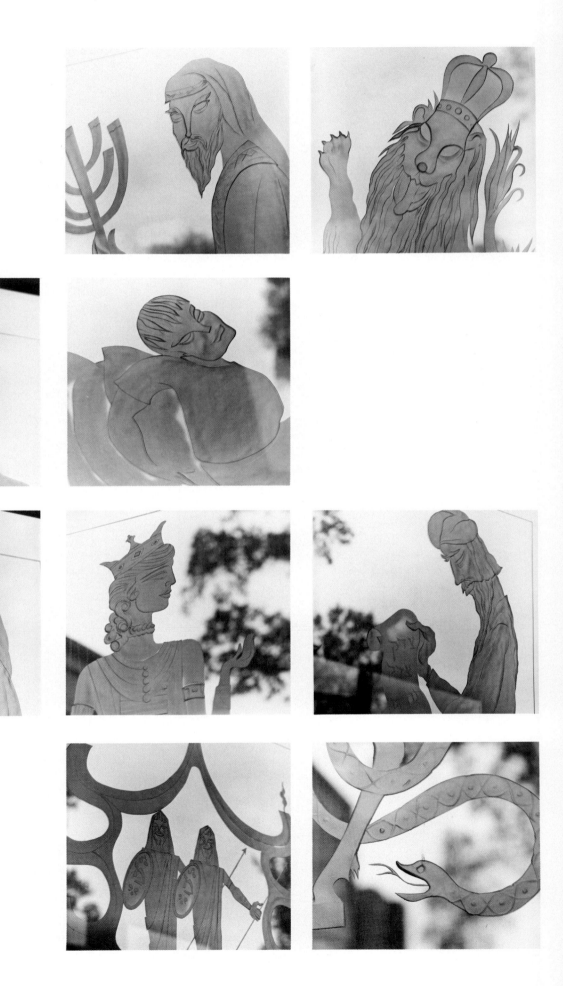

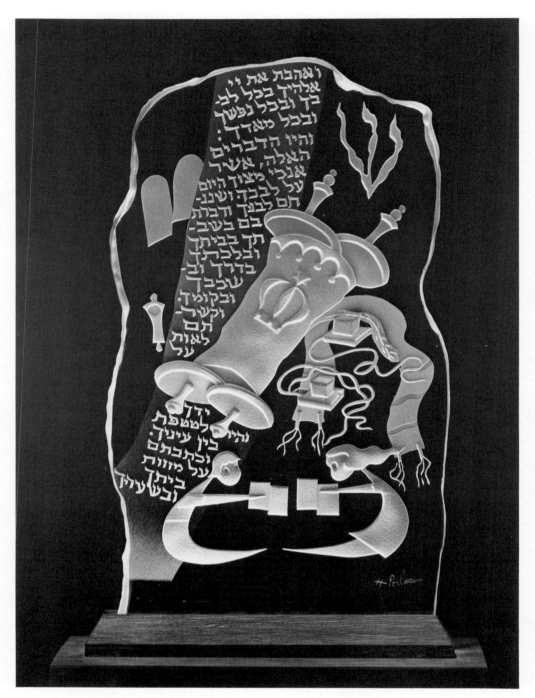

The V'Havta
"You shall love the Lord your God with all your heart, with all your soul and with all your might. Set these words which I command you this day upon your heart. Teach them diligently to your children, speaking of them when you sit in your house, when you walk on your way, when you lie down and when you rise up. Bind them as a sign upon your hand; let them be frontlets between your eyes; write them upon the doorposts of your house and upon your gates."

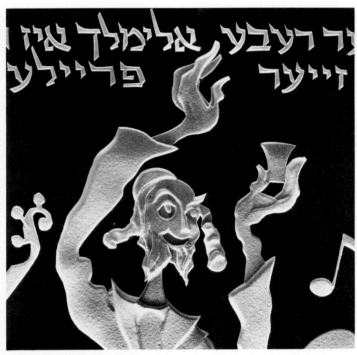

Rebbe Elimelech (detail)

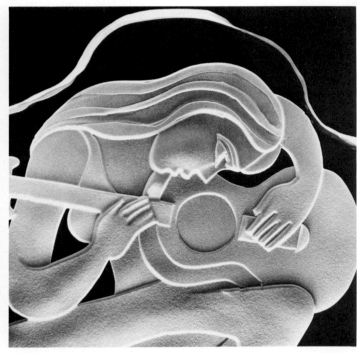

The Folksinger (detail)

Rodeo (detail)

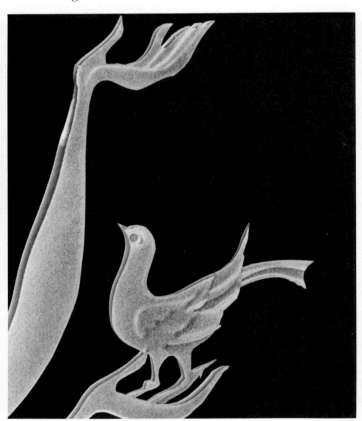

A Woman of Valor (detail)

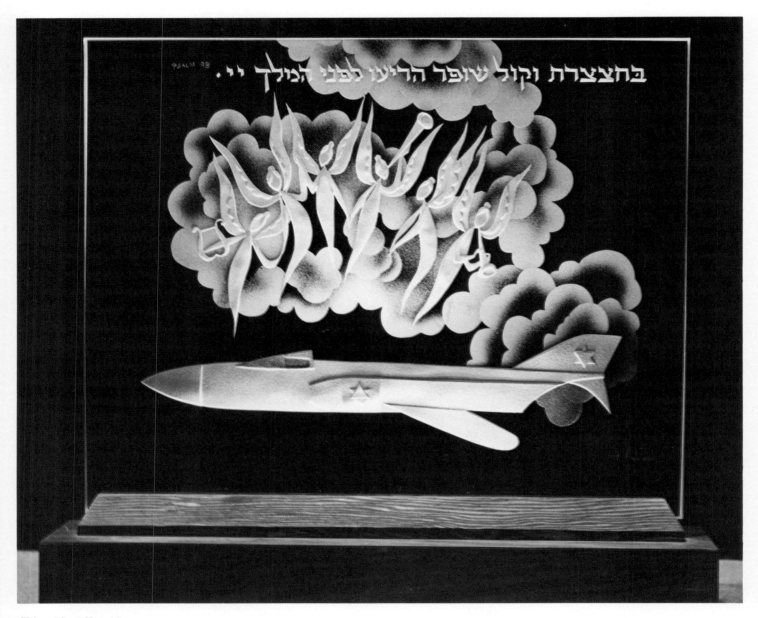

Triumph at Entebbe
"With trumpets and the sound of the
horn, acclaim thy King, the Lord."
(Psalm 98)

"Perlman transforms glass into a creative world of
fantasy and craftsmanship, literally blasting and
carving his way to new dimensions."

Reese Palley, Art Dealer

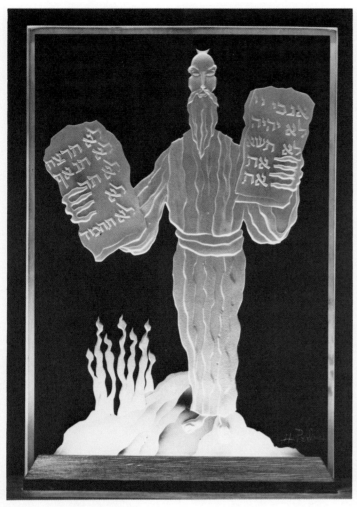

Moses on Mt. Sinai

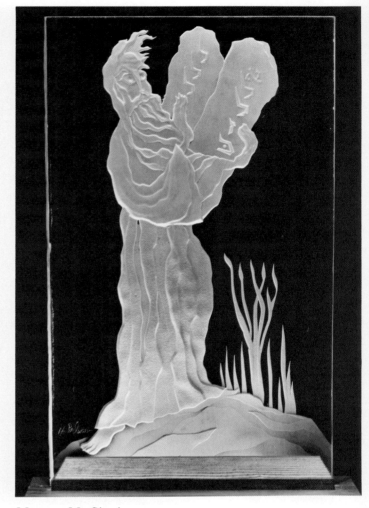

Moses on Mt. Sinai

62

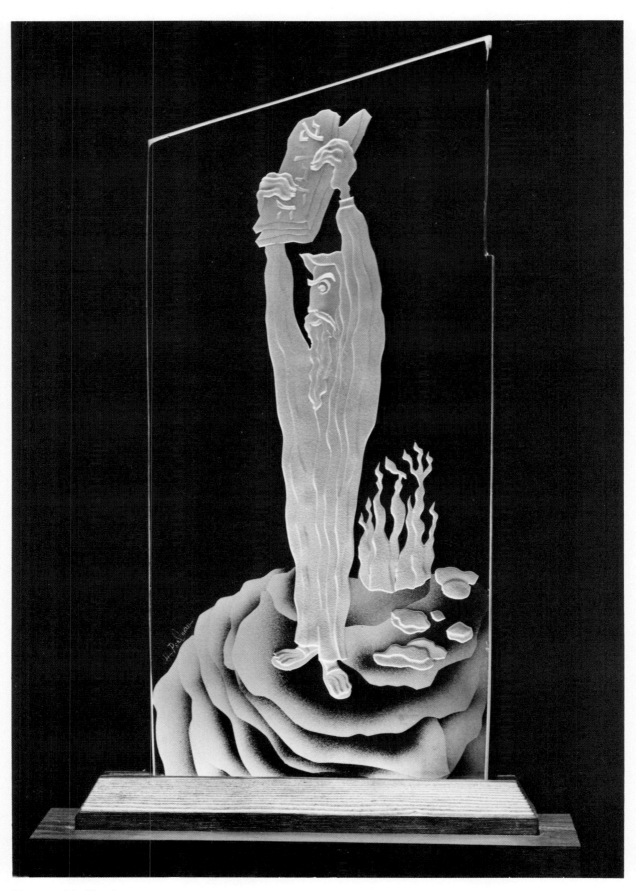

Moses on Mt. Sinai

63

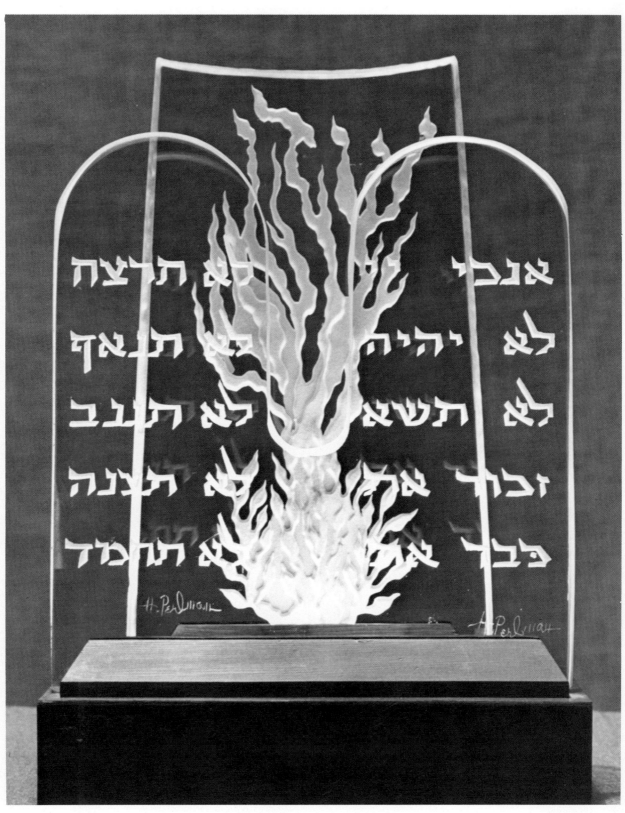

The Decalogue
The Ten Commandments and the Burn-
ing Bush, one set behind the other, to
form a double sculpture.

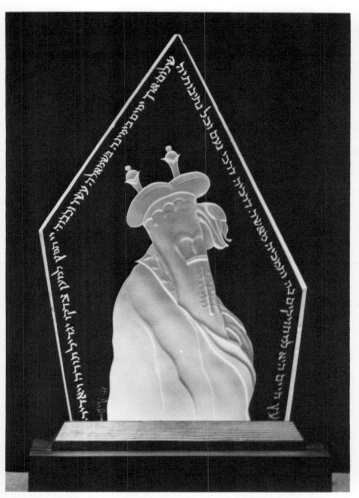

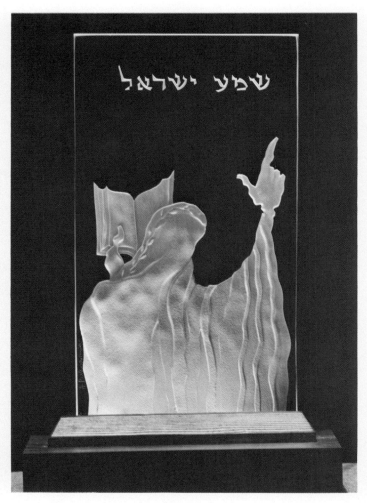

Etz Hayim: Tree of Life
"It is a tree of life to those who hold it fast, and all who cling to it find happiness. Its ways are ways of pleasantness and all its paths are peace. Length of days is in its right hand; in its left hand are riches and honor. It pleased the Lord, for his righteousness' sake, to magnify the Torah and to glorify it."

Sh'ma Yisroel: Hear O Israel

The elegant calligraphy in Hebrew is an important design factor in many of Perlman's works. In some pieces the words float in space; in others they surround the image. Even when they are contained within the confines of the Tablets of the Ten Commandments or the Torah scroll, the shapes of the letters, their curves and points, are infused with life.

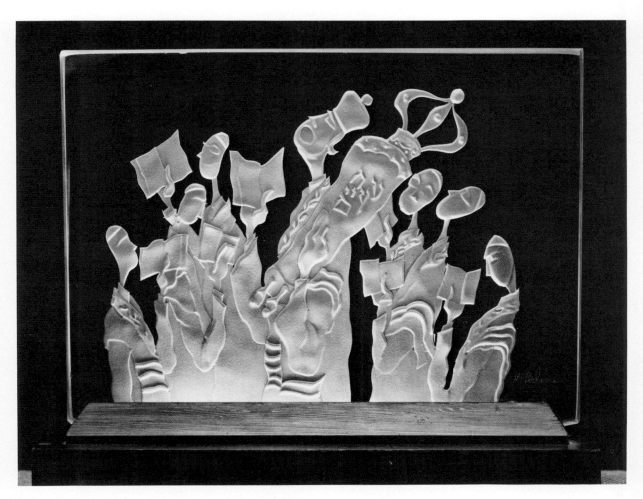

Sabbath Services

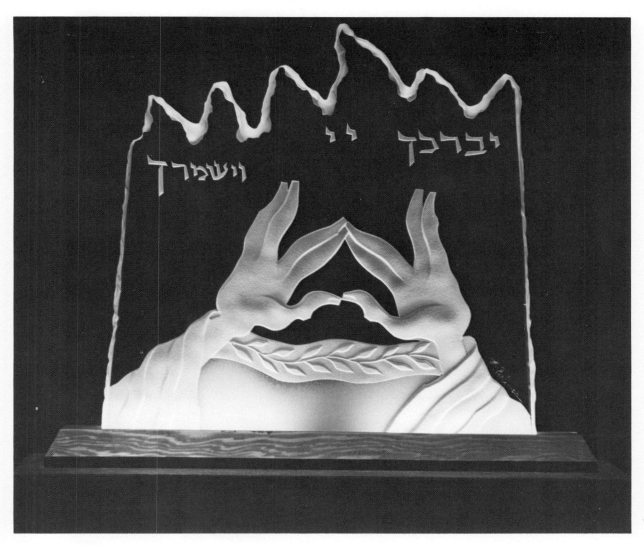

The Priestly Blessing
"May the Lord bless thee and keep thee…"

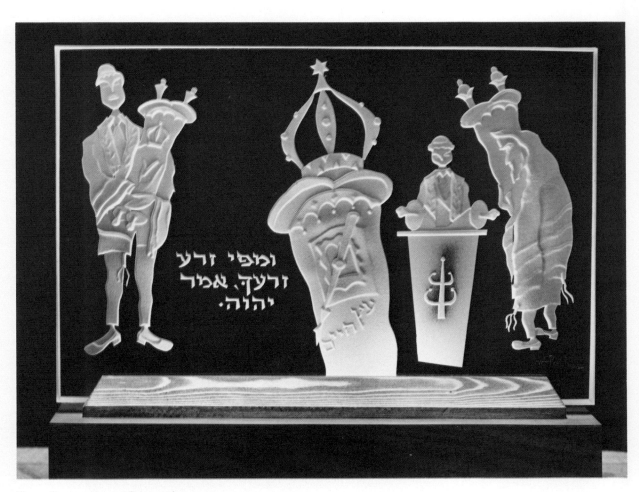

From Generation to Generation
"…the words which I put in your mouth…"

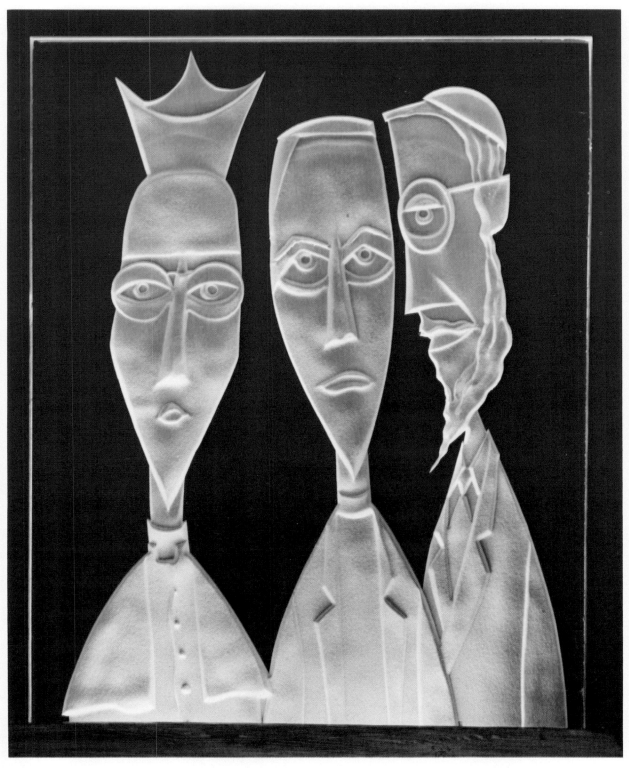

Ecumenical

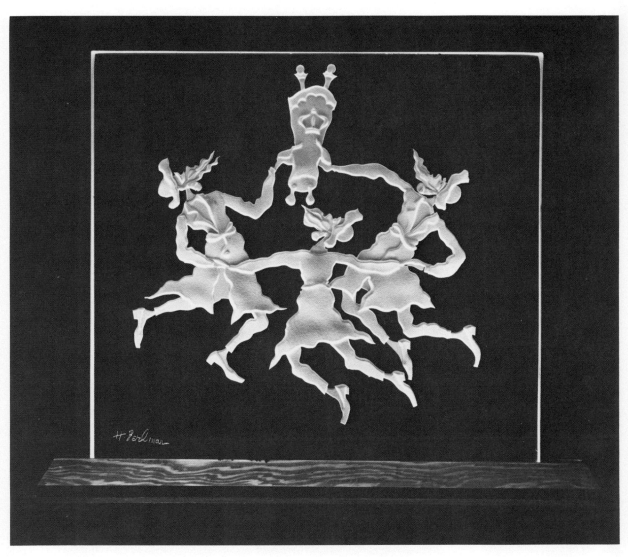

Simchat Torah II

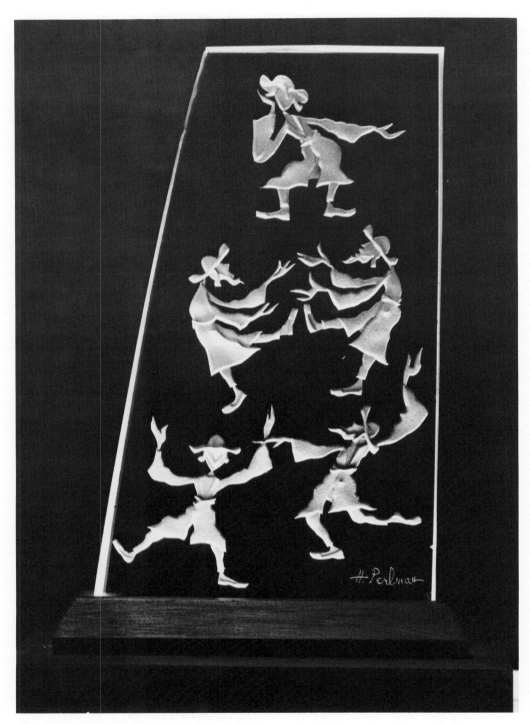

The Golden Chasidim

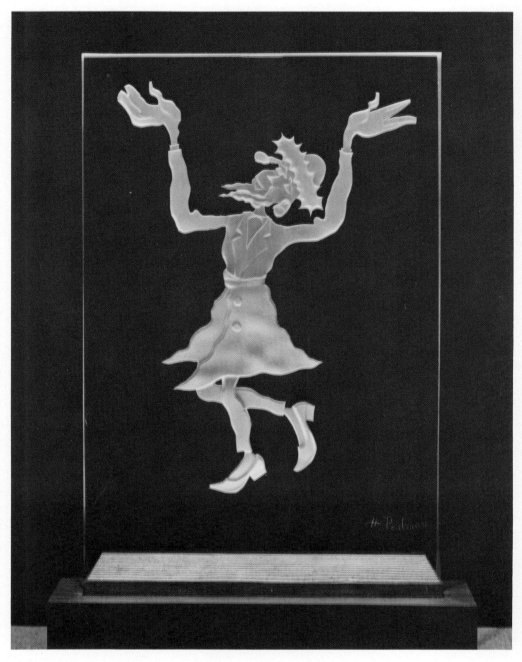

The Chasid

"Even when grieving for my beloved wife, I
never created any sad or depressing works. I
always believed, as it says in the prayer book, that,
"The joy of life shall be fulfilled by the wishes of
our hearts."

Herman Perlman

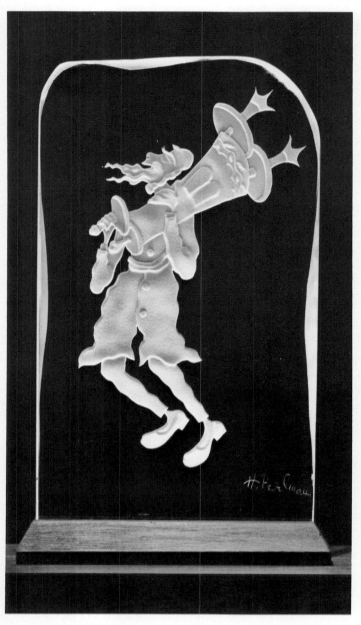

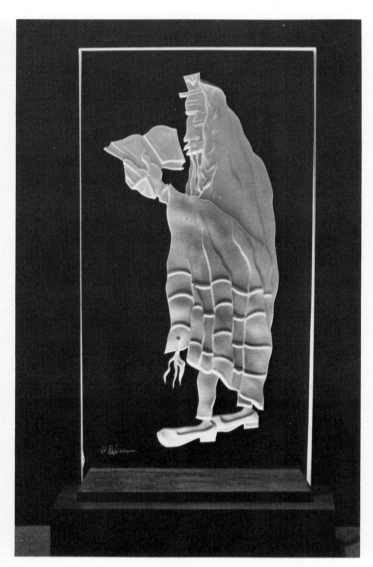

Davening (Praying)

Simchat Torah I

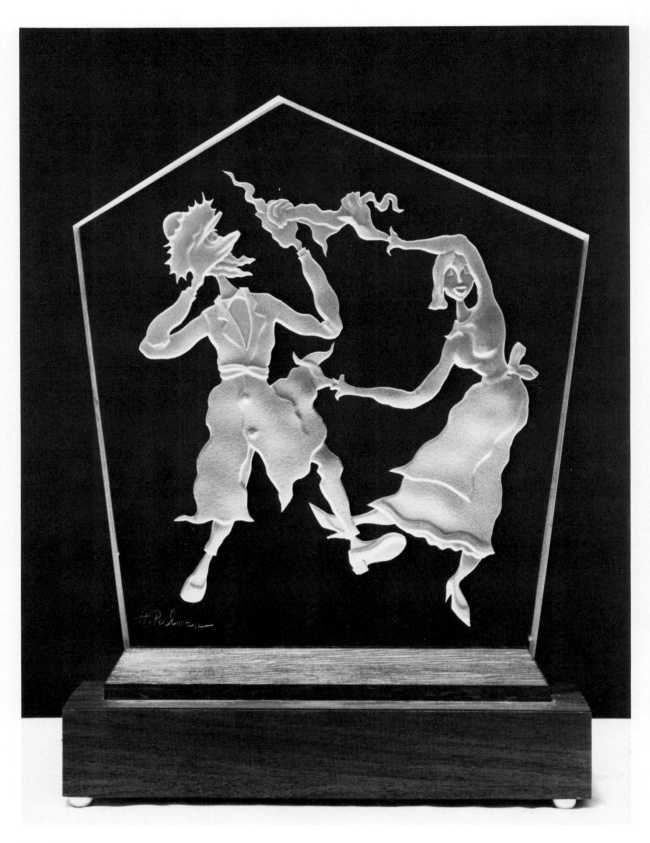

Chasidic Love

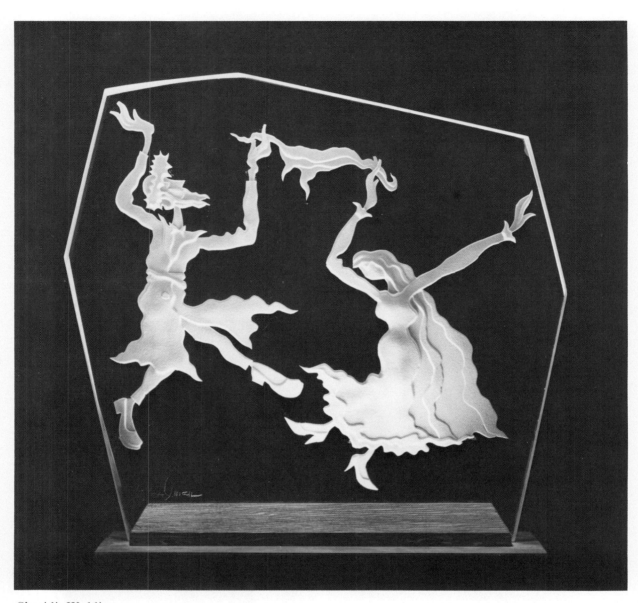

Chasidic Wedding

Movement is essential to the spirit of the work.
The outlines of the human body are etched with a
rhythmic energy which infuses the characters
with life.

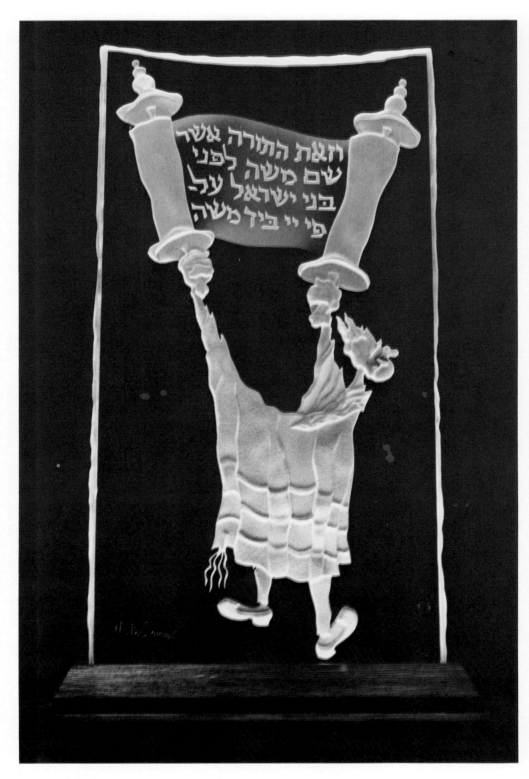

Scrolls of the Law
"This is the Torah which Moses set
before the people of Israel according to
the commandments of the Lord."

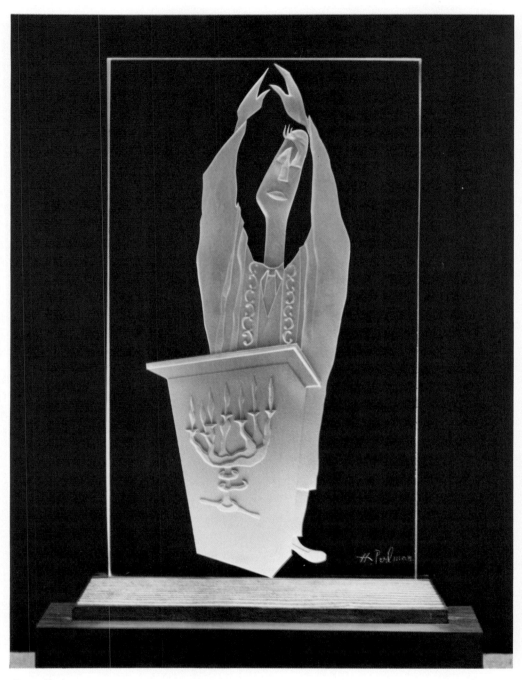

Benediction

When he received one of Perlman's sculptures, Rabbi Abraham J. Heschel quoted from his own book, The Prophets: "Those who have a sense of beauty know that a stone sculptured by an artist's poetic hands has an air of loveliness."

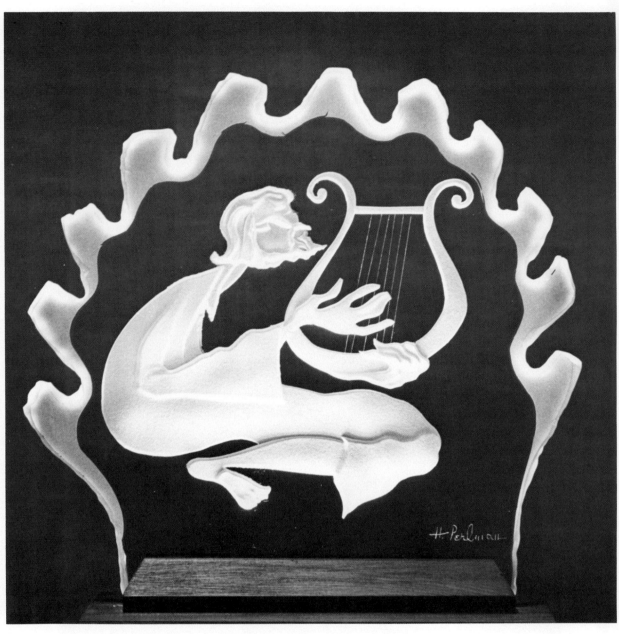

David the Musician

"The definite silhouette of each form, the graceful sinuous outlines, the well-articulated joints of his figures, the feeling of depth and dimension despite the shallow relief into thin glass, the suave textures, are all clearly recognizable as his own."

Ida Jervis, Washington critic and writer

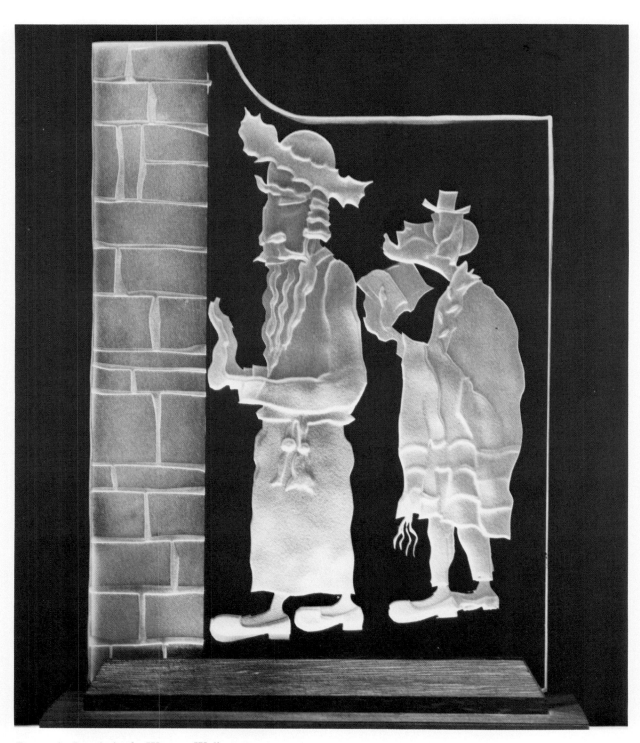

Prayer for Israel: At the Western Wall

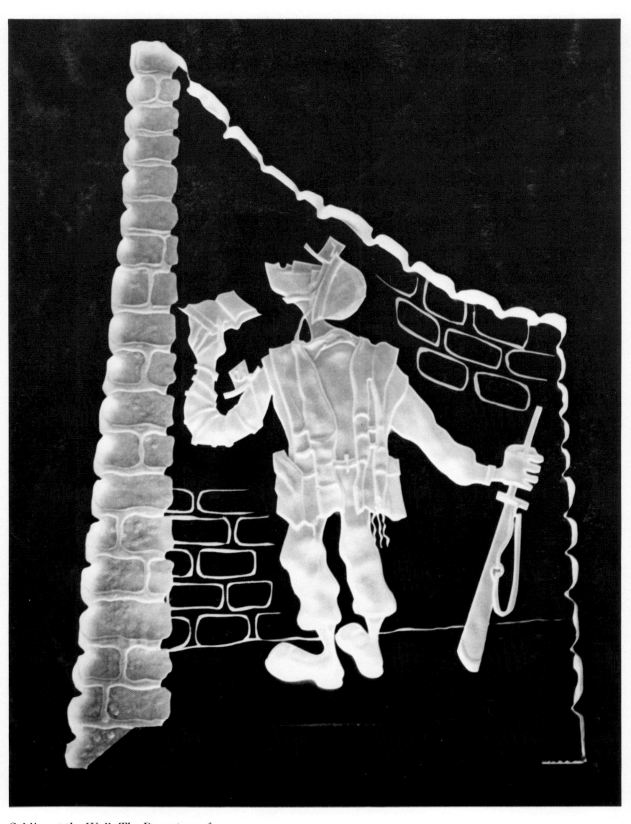

Soldier at the Wall: The Recapture of Jerusalem

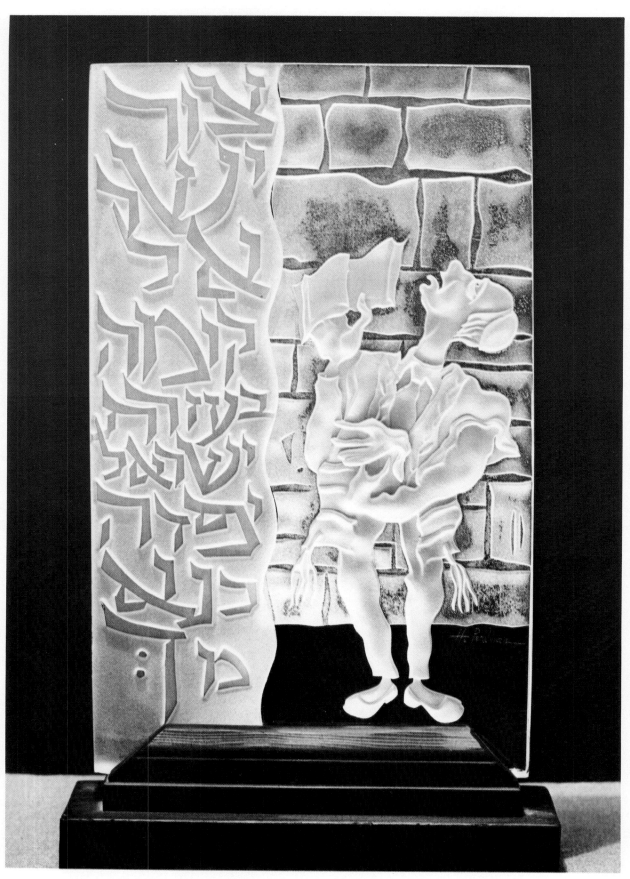

"O Rock of Israel, come to Israel's help.
Fulfill your promise of redemption."
(Perlman places his own image at the
Wall)

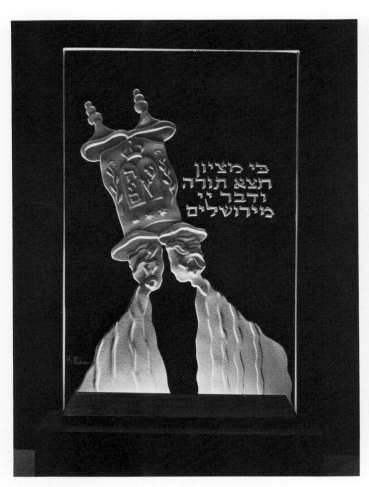

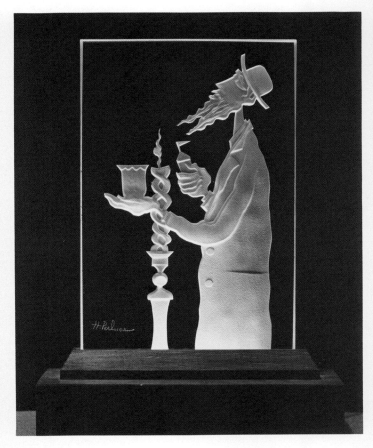

Havdalah

Out of Zion
*"Out of Zion shall go forth the Torah and
the word of the Lord from Jerusalem."*

82

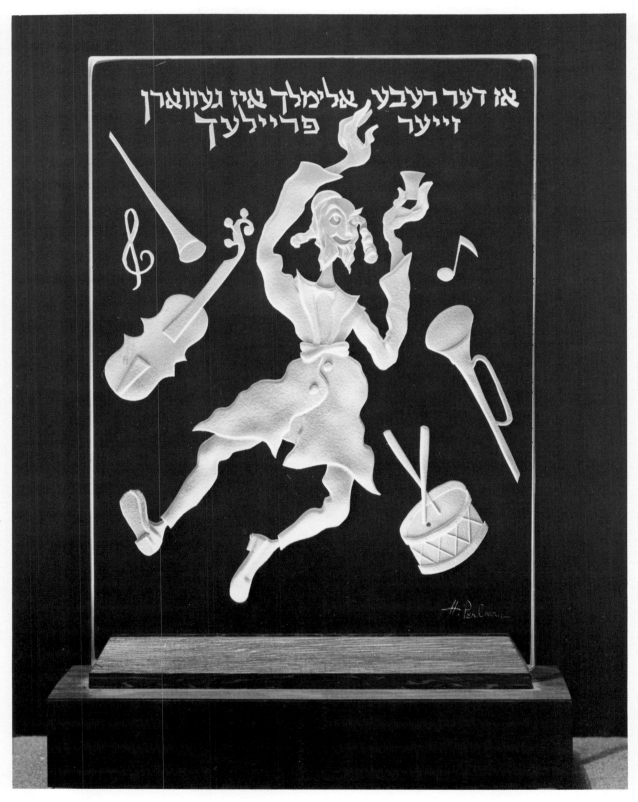

Rebbe Elimelech
"He sang and danced for joy…" from the
words of a traditional Yiddish Purim
song.

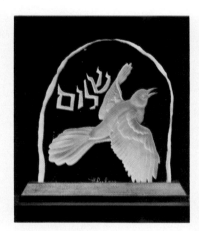

Shalom (Peace)
Perlman's first version of the dove of peace.

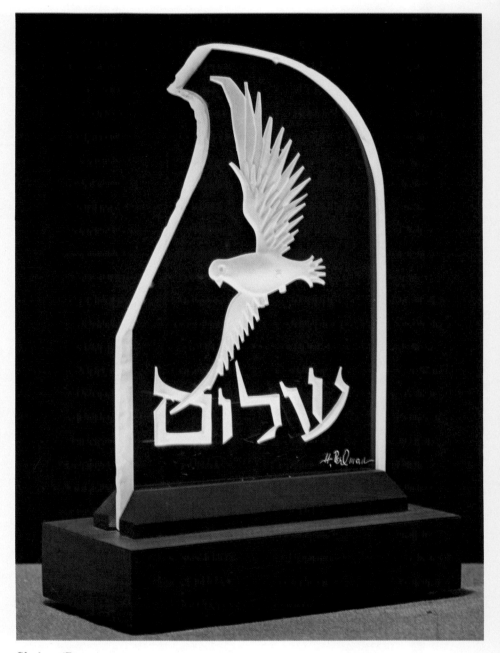

Shalom (Peace)

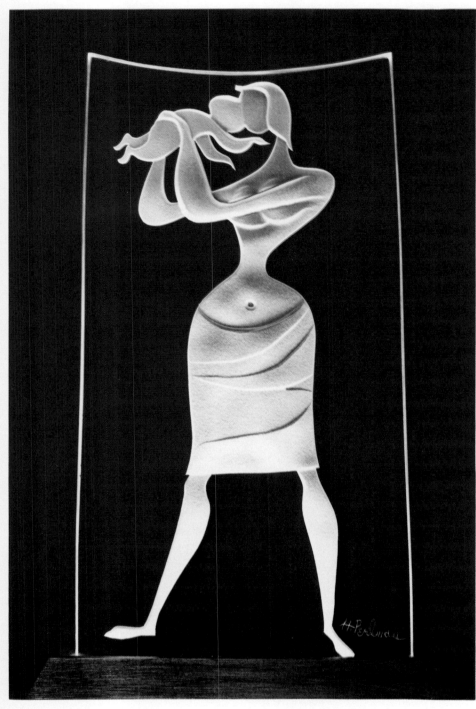

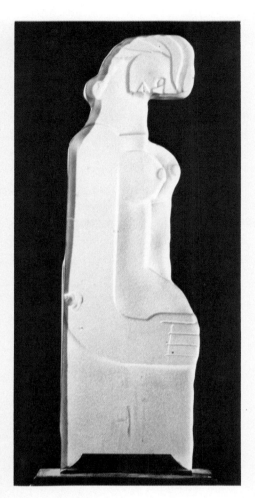

Pregnant Woman

Mother and Child

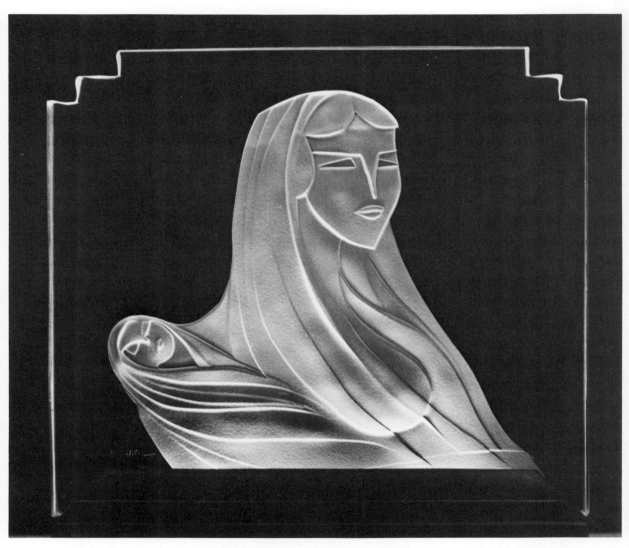

Mother and Child

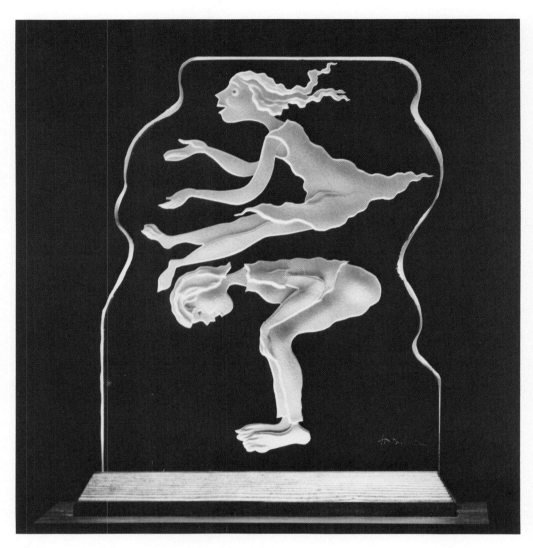

The Joy of Youth

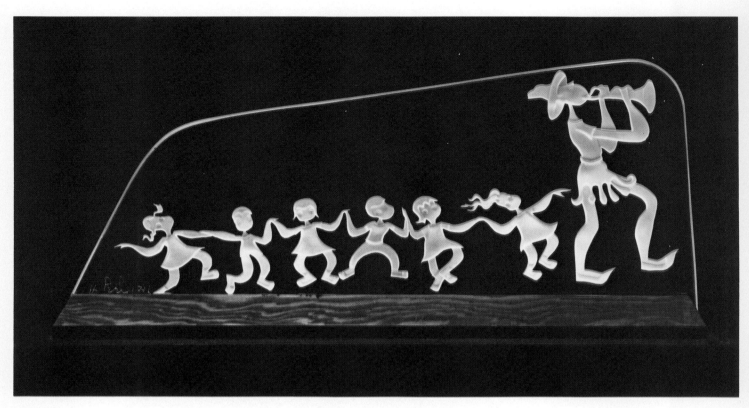

The Pied Piper

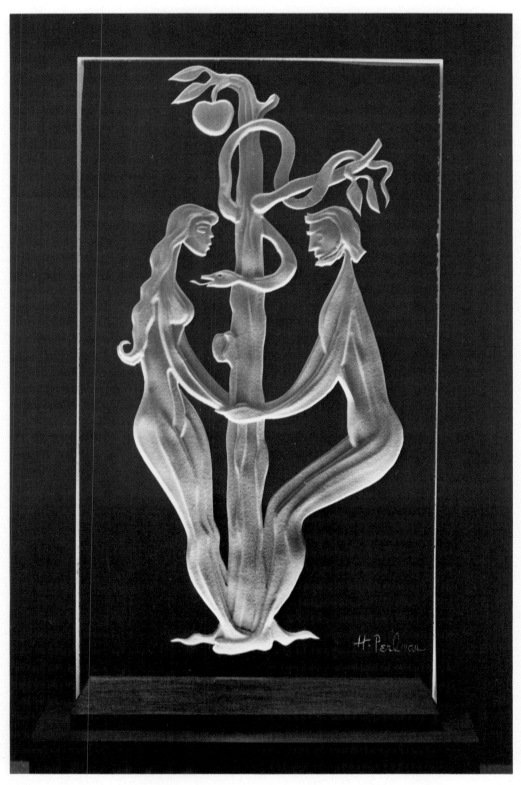

Adam and Eve

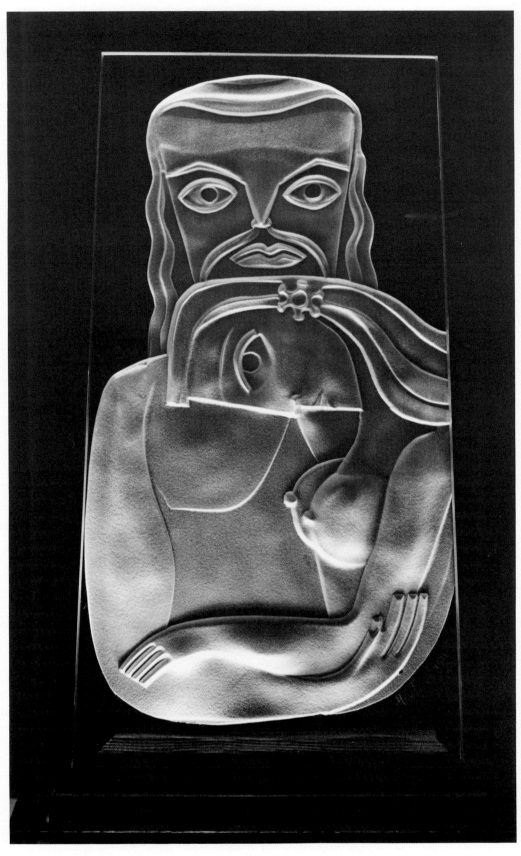

Song of Songs I

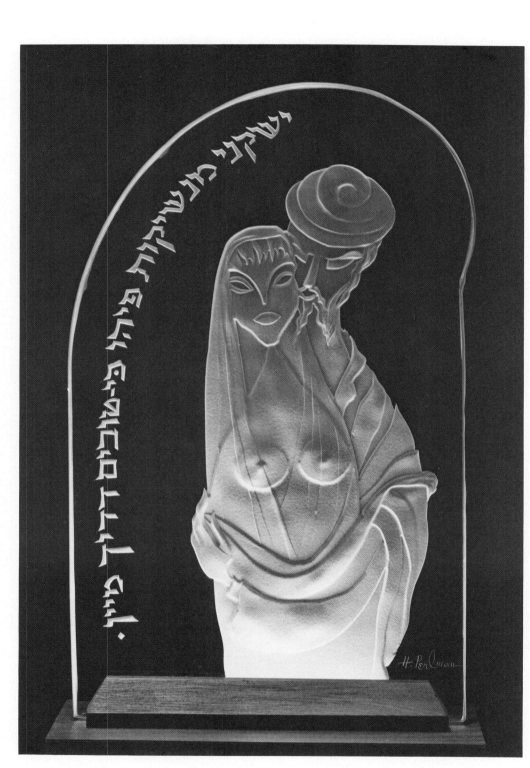

Song of Songs II
"Your caresses are sweeter than wine…"

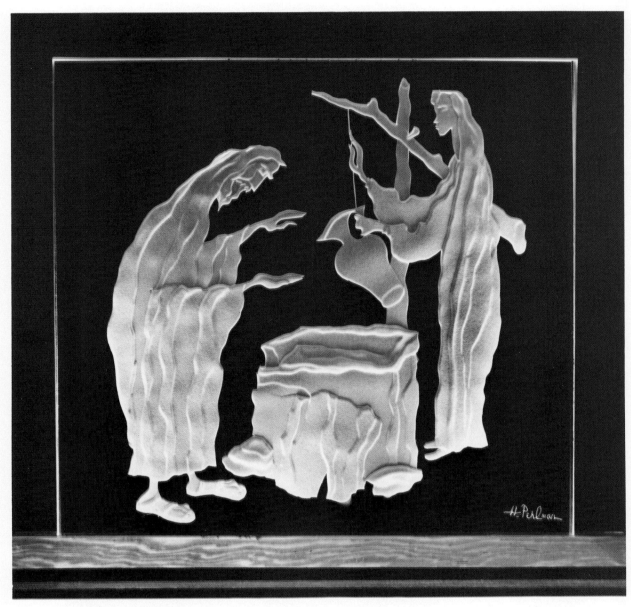

Rebecca at the Well

"No book in human history has called forth or
inspired more artistic activity on all three levels of
decoration, illumination and inspiration than the
Bible. My own reverence for the Bible certainly
nourished my artistic spirit..."

Herman Perlman

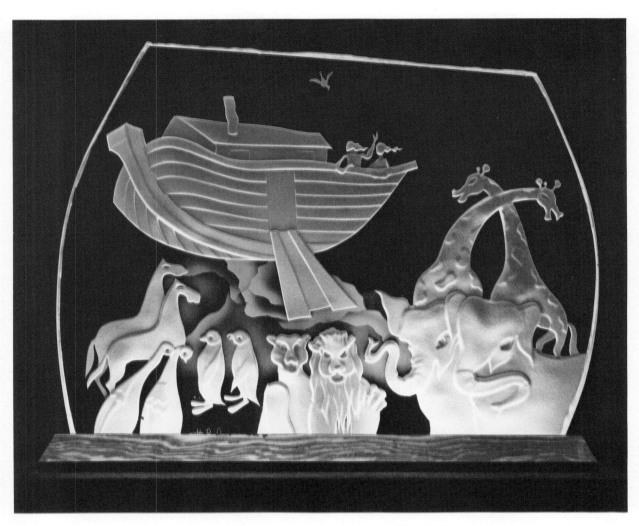

Noah's Ark

"The desire to create is instinctive in mankind.
Glass is the medium I chose to express myself for
my own enjoyment. My great desire was to portray
Biblical subjects in crystal-clear, thick glass as
real, dimensional art pieces."

Herman Perlman

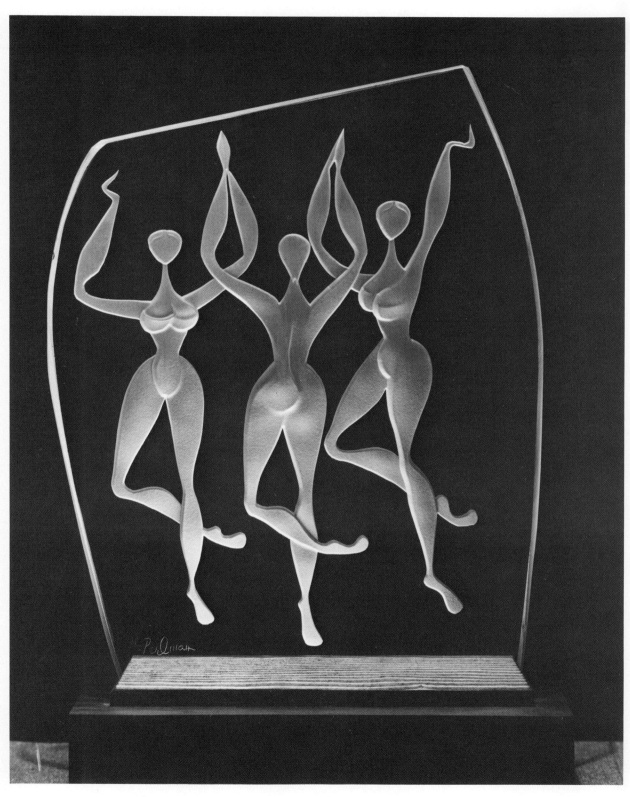

The Three Graces

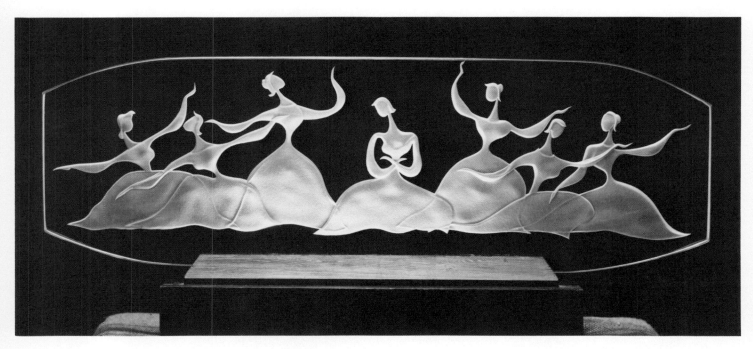

Ballet

A classic stillness is expressed, with the figures
reduced to essential, almost geometric shapes, so
that an abstract moment in time is frozen in the
glass.

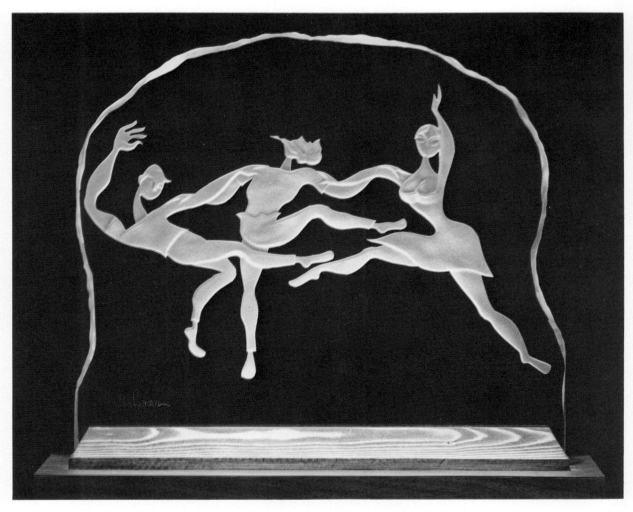

Hora

The dancers seem to leap beyond the confines of
the glass.

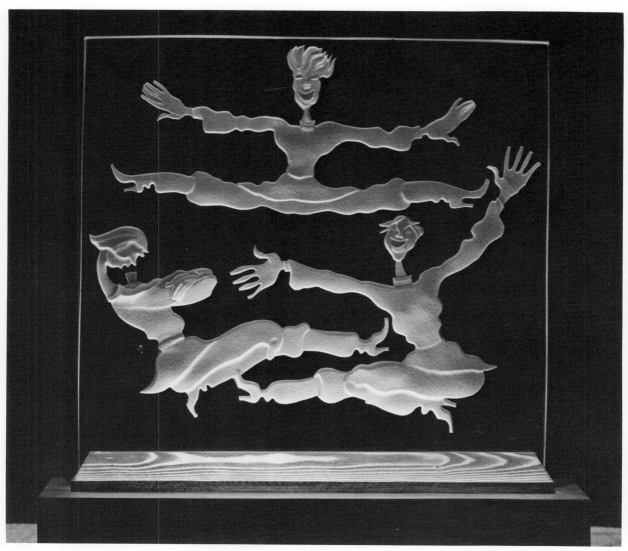

Bolshoi Troika

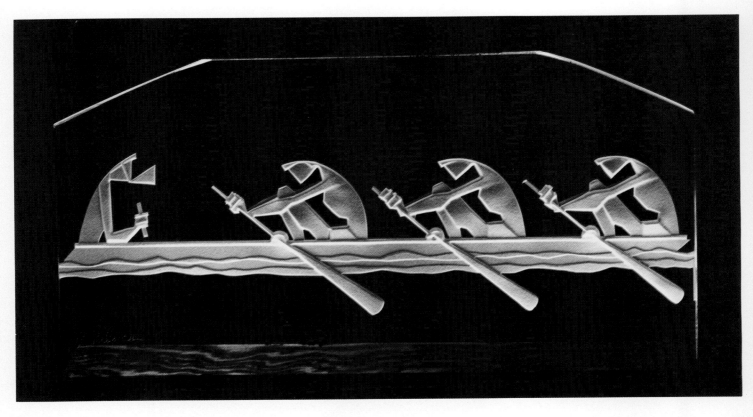

Crew

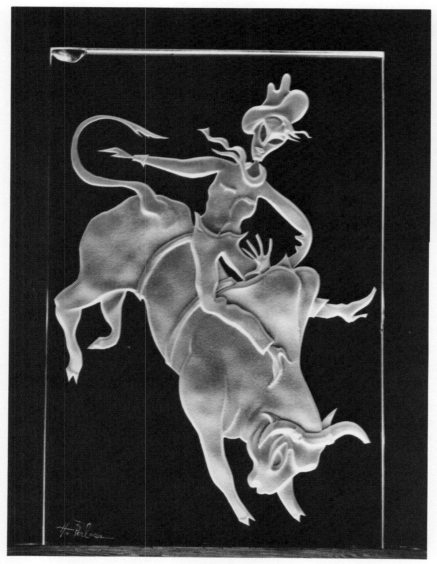

Rodeo

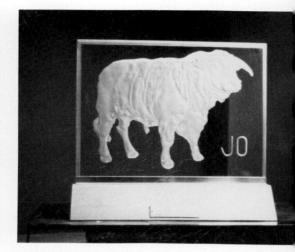

JO, the Brand of LBJ

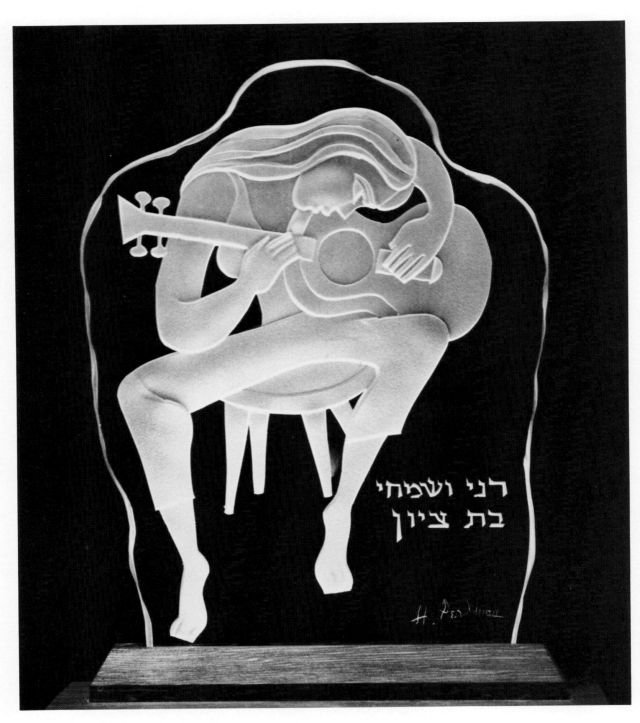

רני ושמחי
בת ציון

The Folksinger
"Sing and dance, O daughter of Zion…"

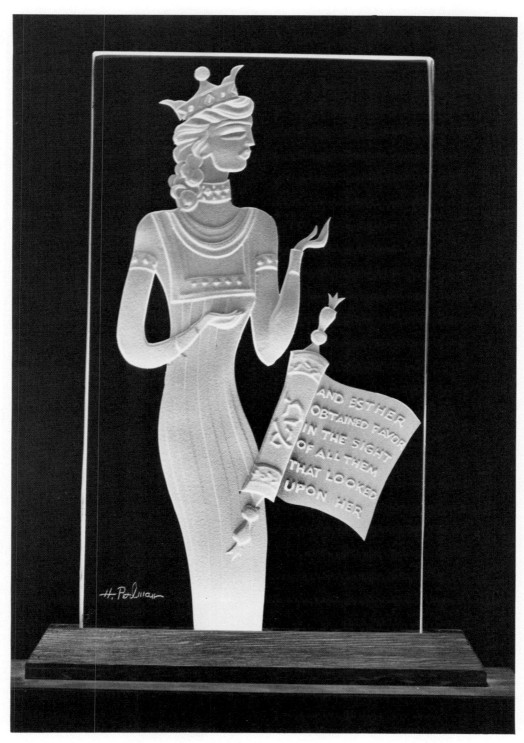

Queen Esther

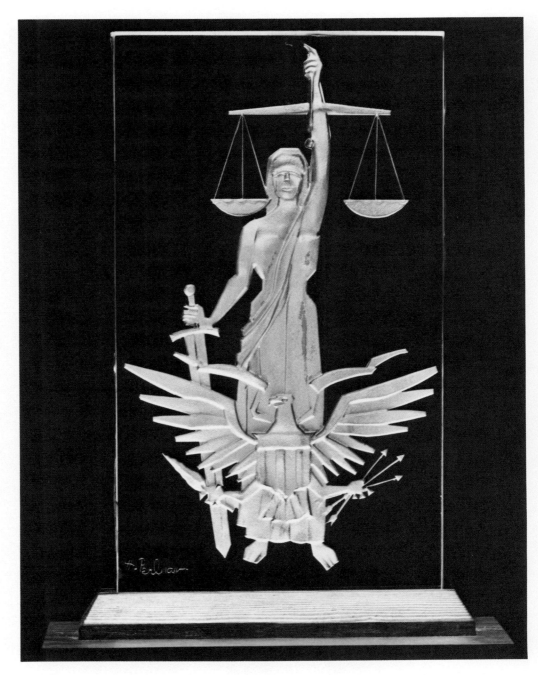

Justice

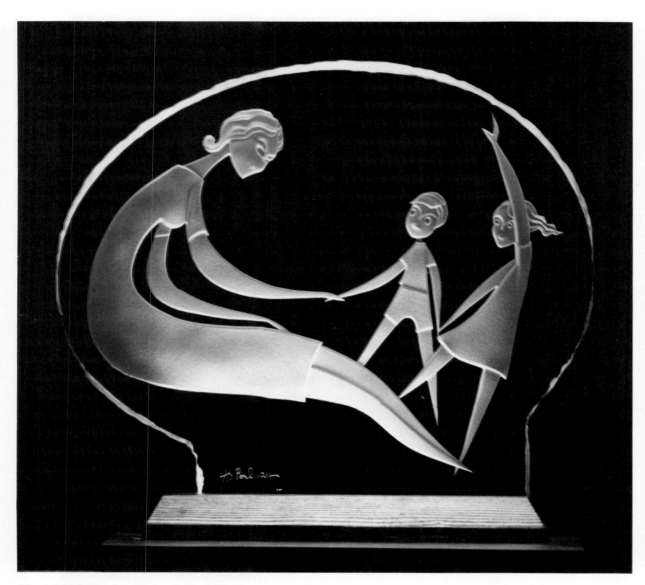

B'nai B'rith Women, Presentation Piece

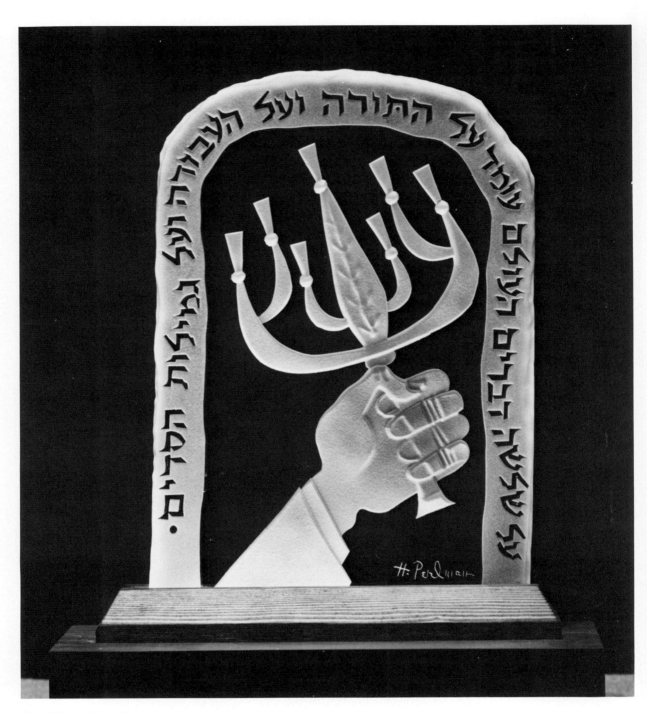

B'nai B'rith Award
"The world is sustained by three things;
by Torah, by worship, by loving deeds."

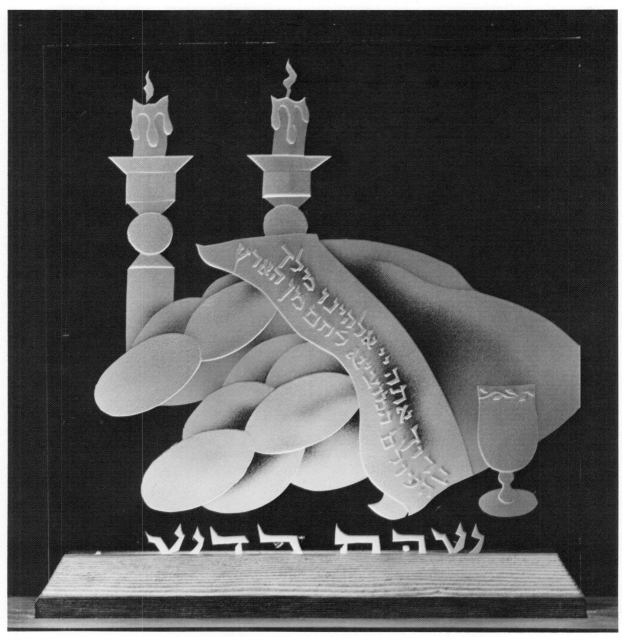

Sabbath
"Blessed art thou, O Lord our God,
Ruler of the universe, who has brought
forth bread from the earth."
Agudath Achim, Alexandria, Virginia

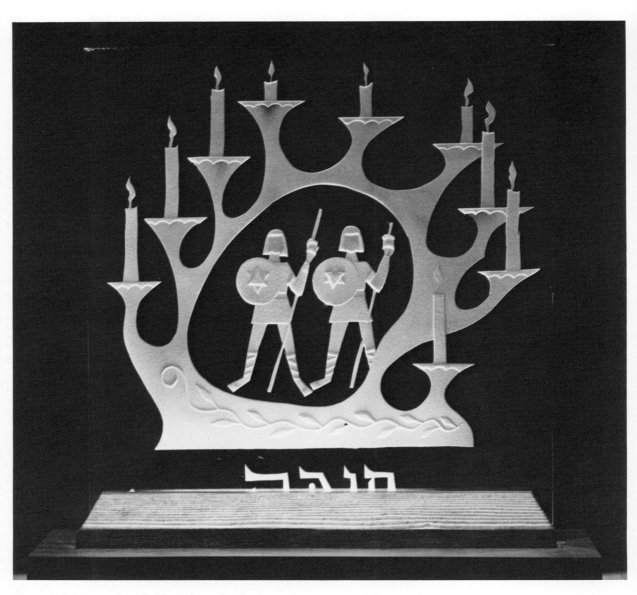

Hannukah Menorah with Maccabean Soldiers
Agudath Achim, Alexandria, Virginia

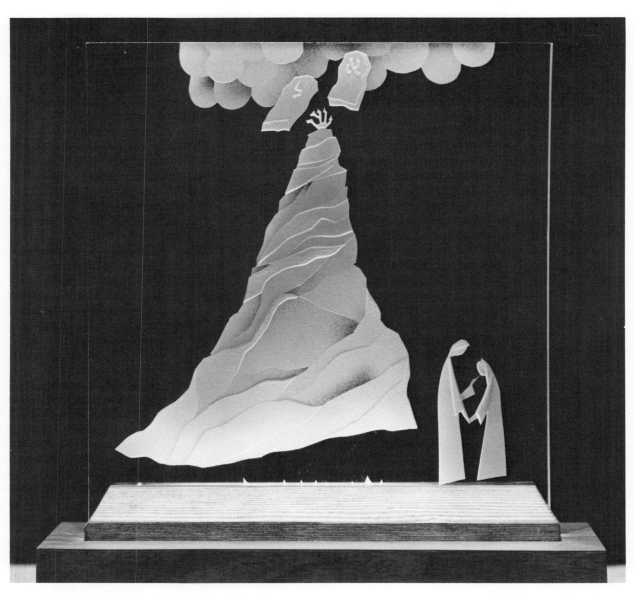

*The Holiday of Shavuot, with Mount
Sinai and the figures of Ruth and Naomi.
Agudath Achim, Alexandria, Virginia*

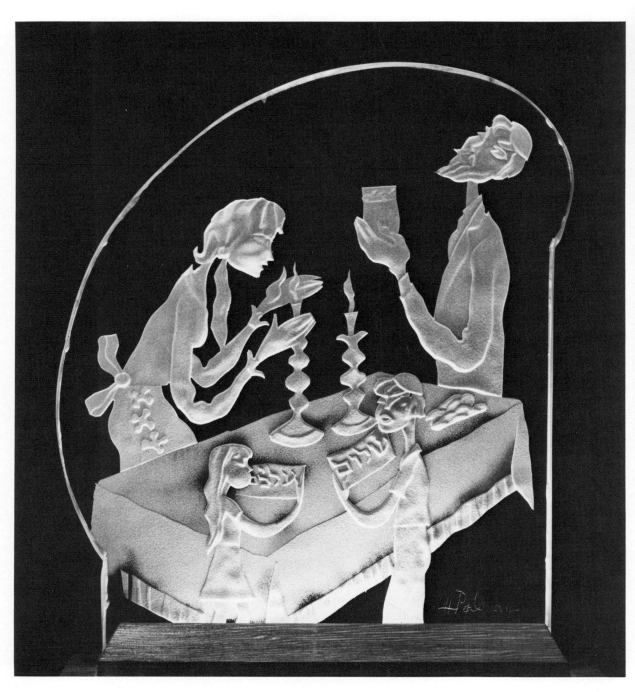

The Joy of Sabbath
"Shalom Aleichem" (Peace among
brethren)

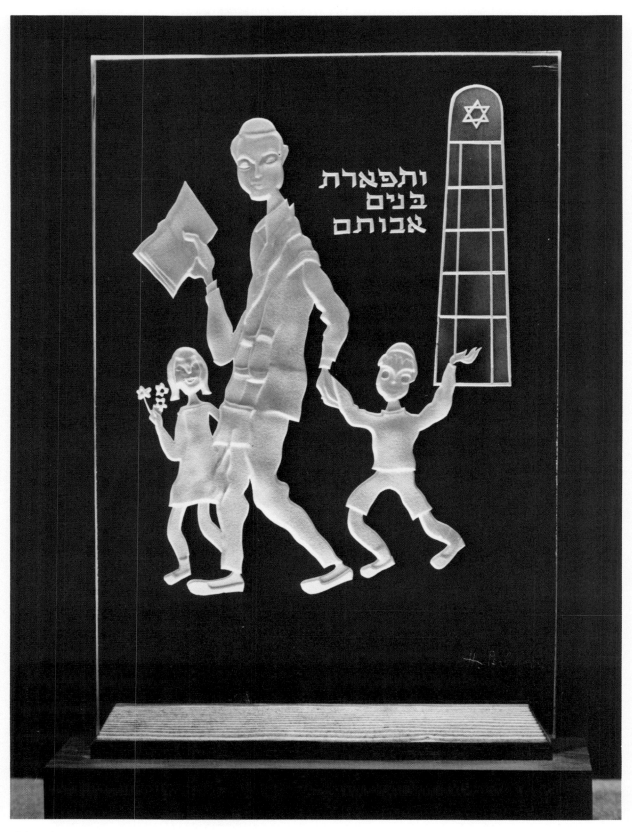

Adoration
"The adoration of children is for their
fathers." (from Pirke Avot, the Sayings of
the Fathers)

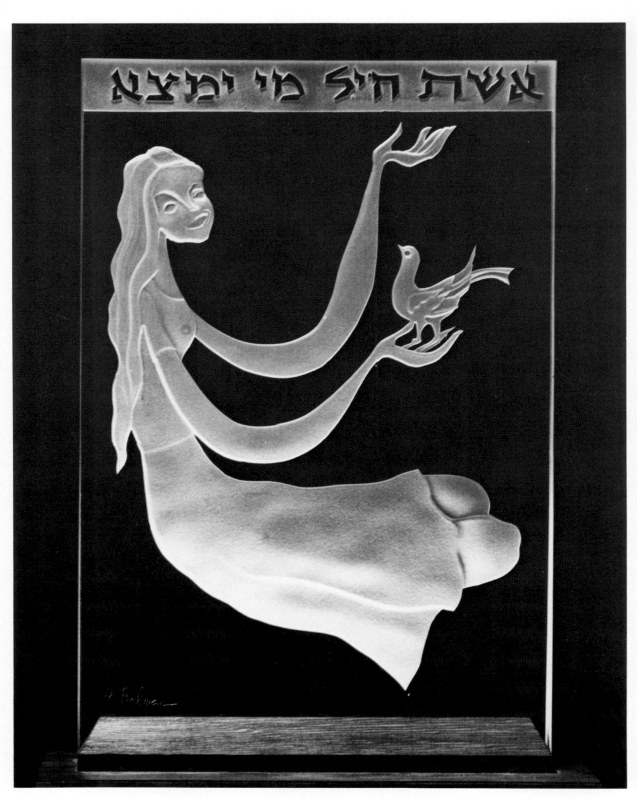

A Woman of Valor

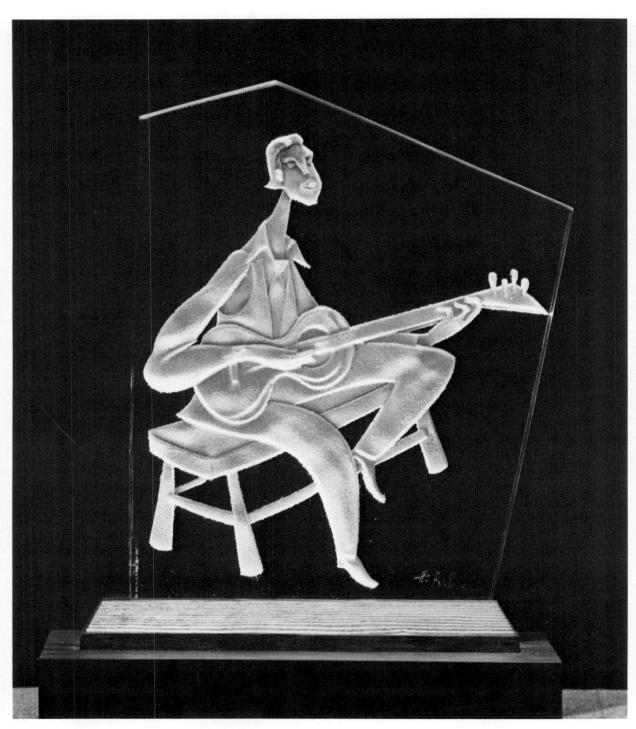

The Folksinger

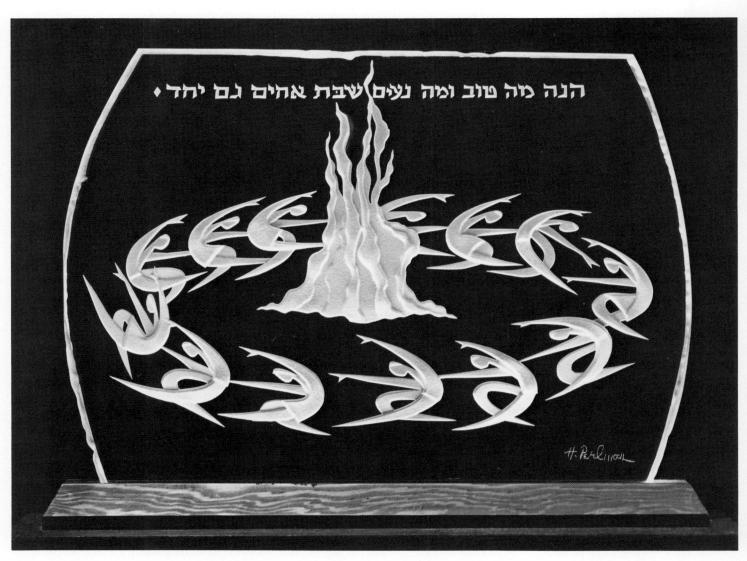

"Hee-nay Ma Tov"
(How good it is for brothers to dwell
together in peace.)

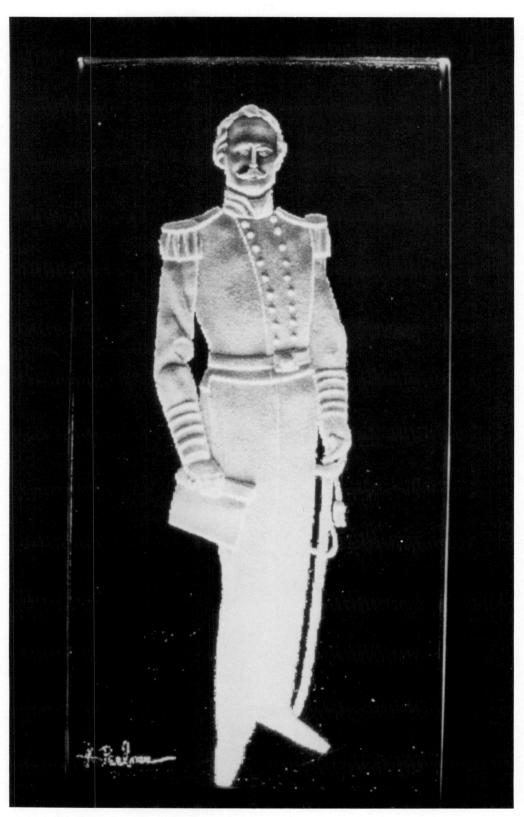

Captain Jonas P. Levy
(collection, B'nai B'rith Klutznick
Museum, Washington, D.C.)

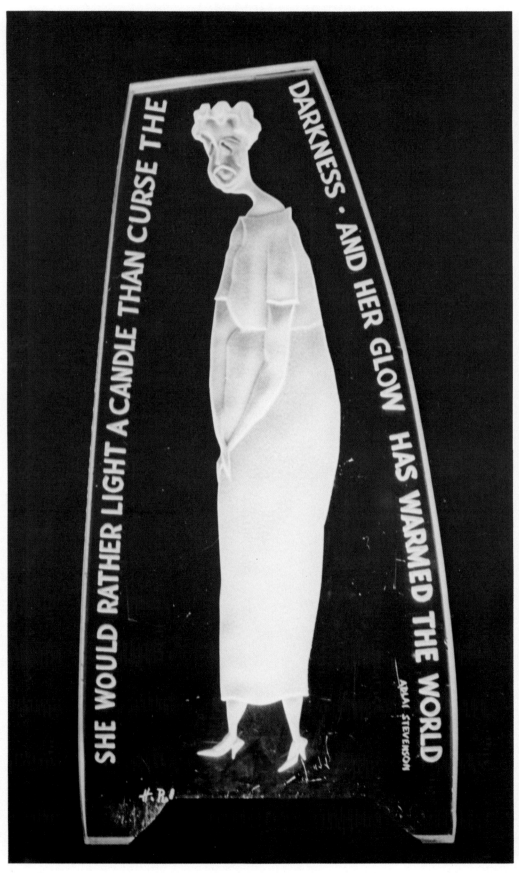

Mrs. Roosevelt

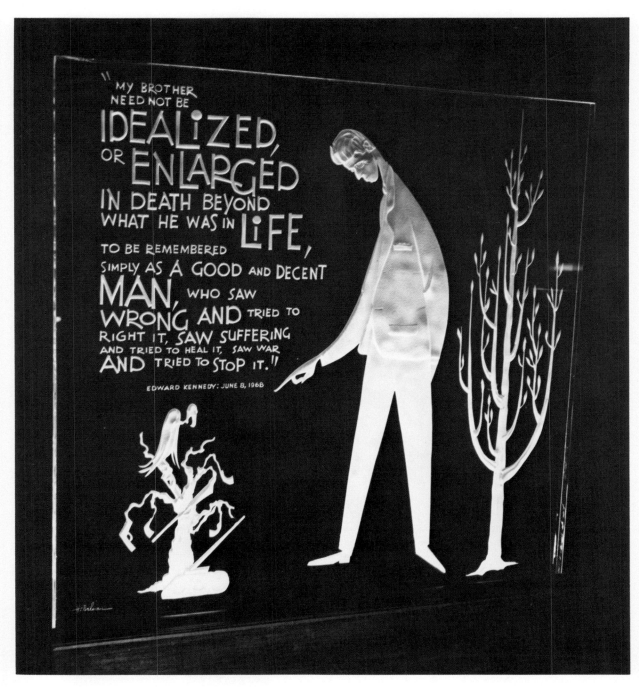

Robert F. Kennedy

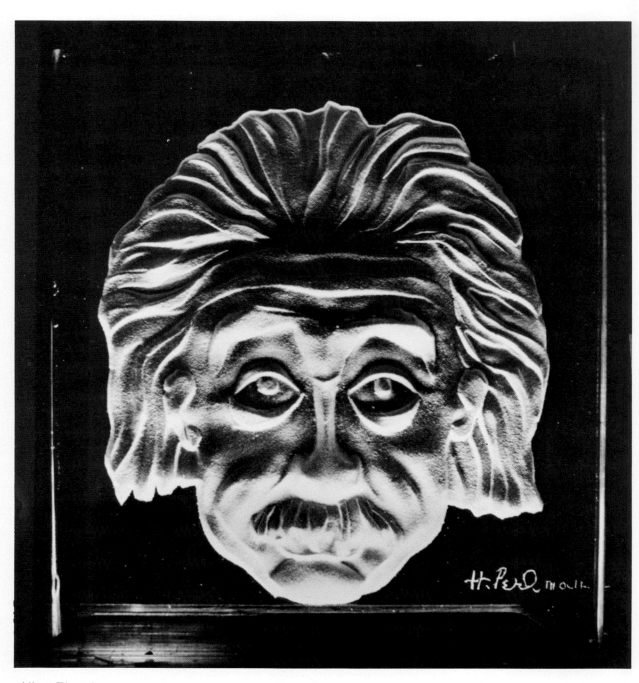

Albert Einstein

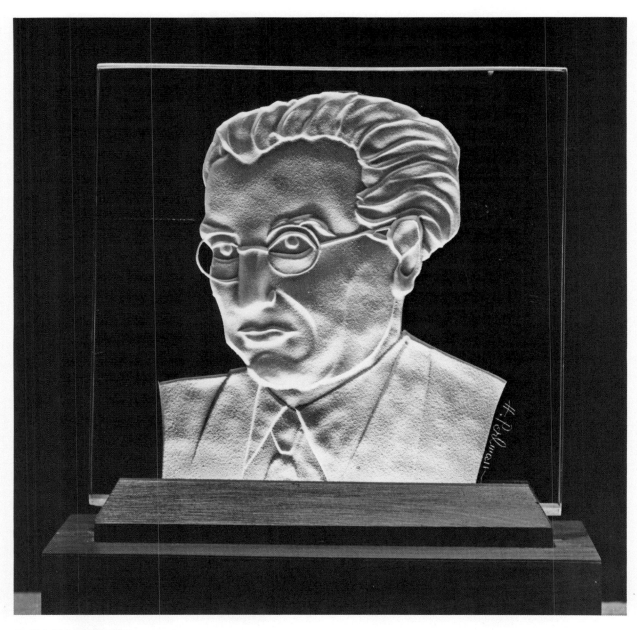

Rabbi Abba Hillel Silver

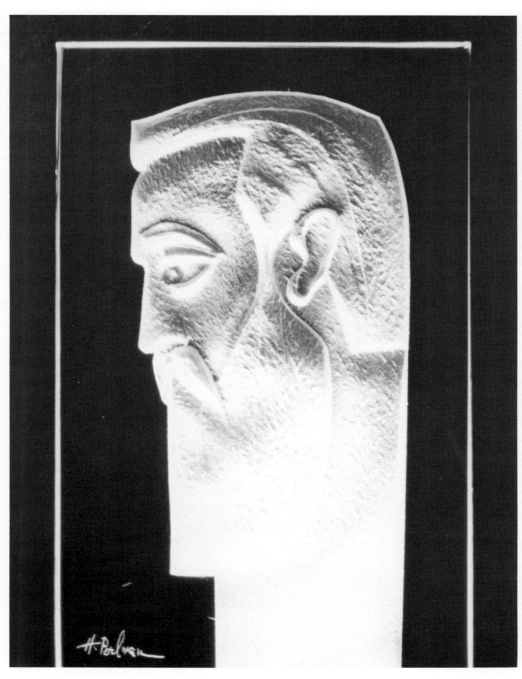

Theodore Herzl
(collection, B'nai B'rith Klutznick
Museum, Washington, D.C.)

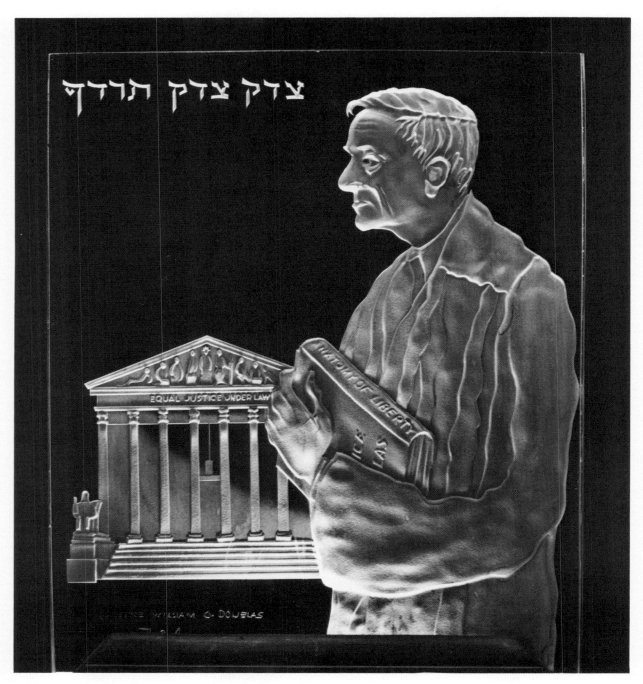

Justice William O. Douglas
"Justice, justice, shall thou pursue."

Collectors

Mr. Harold Alpert, Phoenix, Arizona
Mr. and Mrs. David W. Barg, Houston, Texas
Mr. and Mrs. Jack Belz, Memphis, Tennessee
Mr. and Mrs. Sidney Goldscheider, Baltimore, Maryland
Mr. and Mrs. Meyer Mitchell, Mobile, Alabama
Mr. and Mrs. Harry S. Wender, Washington, D.C.

Other Patrons*

Mr. and Mrs. Sheldon Belousoff, Beverly Hills, California
Mr. and Mrs. Philip Belz, Memphis, Tennessee
Mr. and Mrs. Herman Blum, Scottsdale, Arizona
Mr. and Mrs. Benjamin Clayton, Baltimore, Maryland
Mr. and Mrs. Samuel Dweck, Washington, D.C.
Mr. and Mrs. Hyman Halpern, Chevy Chase, Maryland
Mr. Jerold Hoffberger, Baltimore, Maryland
Ms. Marilyn Lewis, Los Angeles, California
Mr. and Mrs. Nathan Metz, Chevy Chase, Maryland
Mr. and Mrs. Joseph Meyerhoff, Baltimore, Maryland
Mr. and Mrs. Alvin Newmeyer, Washington, D.C.
Dr. and Mrs. Julius Piver, Bethesda, Maryland
Mrs. Eileen Roberts, Houston, Texas
Mr. Art Rooney, Pittsburgh, Pennsylvania
Mr. and Mrs. Jerome Rosenberg, Baltimore, Maryland
Mr. and Mrs. Harry Spector, Silver Spring, Maryland
Mr. and Mrs. Maurice Spiegle, Minneapolis, Minnesota

Award Recipients

Raul Castro, Governor of Arizona
Supreme Court Justice Tom C. Clark
Mr. and Mrs. Melvin Cohen
Mr. Samuel P. Cohen
Supreme Court Justice William O. Douglas
Ambassador Simcha Dinitz of Israel
Mr. and Mrs. Thomas Fischandler, Washington, D.C.
Judge Henry J. Friendly, New York
Bishop Gerasimos, Pittsburgh
Mrs. Janice W. Goldston

Owners of five or more glass sculptures

Ambassador Avram Harmon of Israel
Mr. and Mrs. Alexander Hassan, Washington, D.C.
Ambassador Chaim Herzog of Israel
Vice President Hubert H. Humphrey
Israeli Rescuers of Entebbe
Jim Irwin, Astronaut
Senator Henry Jackson
Senator Jacob Javits
President Lyndon B. Johnson
Danny Kaye, Comedian
Mrs. Abraham Kay, Chevy Chase, Maryland
Mr. and Mrs. Jack Kay, Chevy Chase, Maryland
Ephraim Katzir, President of Israel
President John F. Kennedy
Mr. Joel Klein
Mr. Philip Klutznick, Secretary of Commerce
Mr. Allen Levin, Houston, Texas
Governor Marvin Mandel of Maryland
Mr. and Mrs. Oscar Margulies
Mr. and Mrs. Maurice Maser
Mr. Paul Mason, Bethesda, Maryland
Prime Minister Golda Meir of Israel
Vice President Walter Mondale
Chuck Noll, Pittsburgh Steelers Coach
Arnold Palmer, Golfer
Drew Pearson, Journalist
Mr. and Mrs. Harry Plotkin
Mr. Morris Pollin, Washington, D.C.
Governor James Rhodes, Ohio
Mr. Richard Rodgers, Composer
Senator Hugh Scott
William D. Shaefer, Mayor of Baltimore
Governor Raymond P. Shaefer, Pennsylvania
Governor Milton Shapp, Pennsylvania
Rabbi and Mrs. Stanley Z. Siegel
Beverly Sills, Director, New York City Opera
Judge John Sirica
Edgar B. Speer, Chairman, U.S. Steel
Rabbi Joseph P. Sternstein, Roslyn, New York
President Harry S. Truman
Rabbi and Mrs. Mitchell Wohlberg, Baltimore

1963 Washington Hebrew Congregation, Washington, D.C.
National Housing Center, Washington, D.C.

1964 B'nai B'rith, Washington, D.C.
Arlington-Fairfax Jewish Center, Virginia
Chizuk Amuno Congregation, Pikesville, Maryland

1965 Adas Israel, Washington, D.C.
Washington Hebrew Congregation, Washington, D.C.

1966 Jewish Community Center, Columbus, Ohio

1967 Ambassador's Ball, Washington, D.C.
Adas Israel, Washington, D.C.
Gallery Reese Palley, Atlantic City, New Jersey
Temple Beth El, Baltimore, Maryland

1968 Jewish Community Center, Detroit, Michigan
Stamford Jewish Center, Stamford, Connecticut
Temple Beth El, Baltimore, Maryland

1969 Ambassador's Ball, Shaar Hashomayim, Montreal
Chizuk Amuno Congregation, Pikesville, Maryland
Jewish Community Center, Detroit, Michigan
Taylor Road Synagogue, Cleveland Heights, Ohio
Union of American Hebrew Congregations Biennial,
Miami, Florida
YM/YWHA, Pittsburgh, Pennsylvania
Linden Hill Hotel, Bethesda, Maryland

1970 B'nai B'rith Klutznick Museum, Washington, D.C.
Isaac M. Wise Temple, Cincinnati, Ohio
Wilshire Boulevard Temple, Los Angeles, California
Jewish Community Center, Baltimore, Maryland
Jewish Community Center, Bridgeport, Connecticut
Jewish Community Center, Atlanta, Georgia
Manor House, Newport News, Virginia
Temple Beth Israel, Coral Gables, Florida
Ambassador's Ball, Baltimore, Maryland

1971 Washington Hebrew Congregation, Washington, D.C.
Congregation Sons of Israel, Allentown, Pennsylvania
Jewish Community Center, Bridgeport, Connecticut
Temple Judea, Coral Gables, Florida
Jewish Community Center, Rockville, Maryland
The Jewish Temple, Erie, Pennsylvania
Beth Shalom, Washington, D.C.

1972 Jewish Community Center, Pittsburgh, Pennsylvania
Temple Emanuel, Nashville, Tennessee
Temple Beth Sholom, Miami, Florida
Temple Beth Israel, Phoenix, Arizona
Temple Olef Shalom, Erie, Pennsylvania
Temple Emanuel, Houston, Texas
Temple Beth El, St. Louis Park, Minnesota
Park Synagogue, New York City
Beth Shalom, Washington, D.C.

1973 Jewish Community Center, Atlanta, Georgia
Temple Beth Israel, San Diego, California
Adath Israel Congregation, Cincinnati, Ohio
B'nai Israel, Allentown, Pennsylvania
Wilshire Boulevard Temple, Los Angeles, California
Silver Spring Jewish Center, Silver Spring, Maryland
United Orthodox Synagogue, Houston, Texas
Beth Israel, San Diego, California
Jewish Community Center, Scranton, Pennsylvania

1974 Temple Sinai, Atlanta, Georgia
Temple Beth Sholom, Miami Beach, Florida
Temple Judea, Coral Gables, Florida
Temple Sinai, New Orleans, Louisiana
Temple Oheb Shalom, Baltimore, Maryland
B'nai B'rith Klutznick Museum, Washington, D.C.
Adath Israel Temple, Cincinnati, Ohio
Jewish Community Center, Memphis, Tennessee
Jewish Community Center, Rochester, New York

1975 Agudath Israel Synagogue, Ottawa, Canada
Jewish National Fund Ball, Baltimore, Maryland
Temple Beth Israel, Cherry Hill, New Jersey
Temple Oheb Shalom, Baltimore, Maryland
United Orthodox Synagogue, Houston, Texas
Congregation Beth Yeshurin, Houston, Texas
Wilshire Boulevard Temple, Los Angeles, California

1976 Adas Israel, Washington, D.C.
Beth El Synagogue, Cherry Hill, New Jersey
Charold Gallery, Sarasota, Florida
Jewish Community Center, Bridgeport, Connecticut
Temple Judea, Coral Gables, Florida
Temple Beth Israel, Phoenix, Arizona
Temple Sinai, Atlanta, Georgia
Jewish Community Center, Rochester, New York

1977 Jewish National Fund Ball, Baltimore, Maryland
Temple Sinai, New Orleans, Louisiana

Temple Oheb Shalom, Baltimore, Maryland
Jewish National Fund Ball, Baltimore, Maryland
Jewish Community Center, Rockville, Maryland

1979 B'nai B'rith Klutznick Museum, Washington, D.C.
(permanent exhibit)
College of Jewish Studies, Cleveland, Ohio
Jewish National Fund Ball, Baltimore, Maryland
Temple Beth Israel, Hartford, Connecticut
Beth El Synagogue, Cherry Hill, New Jersey

1980 Beth Tefilah Synagogue, Baltimore, Maryland
Temple Israel, Dayton, Ohio
Jewish National Fund Ball, Baltimore, Maryland

1981 Temple Beth El, Richmond, Virginia
B'nai B'rith Convention, Houston, Texas
Jewish Community Center, Dallas, Texas

1982 Jewish Community Center, Memphis, Tennessee
Temple Israel, Memphis, Tennessee

PERMANENT INSTALLATIONS

Abraham Lincoln National Historical Park, Hodgenville, Kentucky
Adath Israel Congregation, Cincinnati, Ohio
Agudath Achim Congregation, Alexandria, Virginia
Arlington-Fairfax Jewish Center, Virginia
Baltimore Hebrew Congregation, Baltimore, Maryland
Beth El Congregation, Rochester, New York
Beth El Congregation, Baltimore, Maryland
Beth El Congregation, St. Louis Park, Minnesota
Temple Beth Israel, Phoenix, Arizona
Beth Sholom Synagogue, Washington, D.C.
Temple Beth Sholom, Elkins Park, Pennsylvania
Beth Tfiloh, Baltimore, Maryland
Beth Yeshuren Congregation, Houston, Texas
Blair House, Washington, D.C.
B'nai B'rith Klutznick Museum, Washington, D.C.
B'nai Israel Synagogue, Rockville, Maryland
Chizuk Amuno Congregation, Pikesville, Maryland
Temple Emanuel, Houston, Texas
Federal Reserve Board, Washington, D.C.
Temple Hanshe Hessed, Erie, Pennsylvania
Hebrew Home, Rockville, Maryland
Hyatt Regency Hotel, Washington, D.C.
Isaac M. Wise Temple, Cincinnati, Ohio
Jewish Community Center, Bridgeport, Connecticut
Jewish Community Center, Scranton, Pennsylvania
Lincoln University, Oxford, Pennsylvania
Madison National Bank, Washington, D.C.
Mary Washington Hospital, Fredericksburg, Virginia
National Army War College, Ft. McNair, D.C.
National Portrait Gallery, Washington, D.C.
Lillian and Albert Small Jewish Museum, Washington, D.C.
Temple Oheb Shalom, Baltimore, Maryland

Ohr Kodesh Congregation, Chevy Chase, Maryland
The Renwick Gallery, Washington, D.C.
Riggs National Bank, Washington, D.C.
Sacred Heart Church, La Plata, Maryland
Temple Rodef Shalom, Pittsburgh, Pennsylvania
Shaar Hashomayim, Montreal, Quebec
St. Thomas Moore Catholic Church, Arlington, Virginia
United Orthodox Synagogue, Houston, Texas
Virginia World War II Memorial, Richmond, Virginia
Walter Reed Medical Center Chapel, Washington, D.C.
Washington Hebrew Congregation, Washington, D.C.
Wilshire Boulevard Temple, Los Angeles, California
Y.M./Y.W.H.A., Pittsburgh, Pennsylvania

Glass Sculptures

Adam and Eve	89	
Adam's Rib	23	
Adoration	109	
Art, Music and Drama	16	
Asher	58	
Ballet	95	
Benediction	77	
Blessing the Sabbath Candles	16	
Blowing the Shofar	104	
B'nai B'rith Award	104	
B'nai B'rith Women Award	103	
Bolshoi Troika	97	
Chasid	72	
Chasidic Love	74	
Chasidic Wedding	75	
L'Chayim: Golda Meir	35	
Churchill, Winston	33	
Crew	98	
Dan	58	
Dan	58	
Davening	73	
David the Musician	78	
Decalogue	64	
DeGaulle, Charles	33	
DeGaulle, Charles	49	
Dirksen, Everett	48	
Douglas, William O.	34	
Douglas, William O.	119	
Ecumenical	69	
Einstein, Albert	33	
Einstein, Albert	116	
Entebbe	61	
Esther the Queen	58	
Esther the Queen	101	
Etz Hayim	12	
Etz Hayim	65	
Folksinger	60	
Folksinger	100	
Folksinger	111	

Gad	57	
Generation to Generation	68	
Gettysburg Address	29	
Golden Chasidim	71	
Hannuka	106	
Havdalah	82	
Hear O Israel	65	
Hee-nay Ma Tov	115	
Herzl, Theodore	118	
Hora	96	
Issachar	58	
Jacob's Dream	17	
Jerusalem	36	
Jerusalem	38	
JO, Brand of LBJ	99	
Joseph and Benjamin	15	
Joy of Sabbath	108	
Joy of Youth	87	
Justice	102	
Kennedy, Robert F.	115	
Levi	58	
Levy, Captain Jonas P.	113	
"Licht Benchen"	16	
Lincoln	29	
Lincoln	29	
Lion of Juda	58	
Maccabees	57	
Meir, Golda	35	
Moses	32	
Moses on Mt. Sinai	63	
Moses on Mt. Sinai	62	
Moses on Mt. Sinai	62	
Mother and Child	86	
Mother and Child	85	
Naftali	58	
Noah's Ark	93	
Oheb Shalom, Baltimore	56	
Out of Zion	82	
Patriarchs	30	
Pied Piper	88	
Prayer for Israel: At the Western Wall	79	
Pregnant Woman	85	
Priestly Blessing	67	
Procession	14	

Queen Esther	58	
Queen Esther	101	
Rebbe Elimelech	83	
Rebbe Elimelech	60	
Rebecca at the Well	92	
Recapture of Jerusalem	80	
Rock of Israel	81	
Rodeo	60	
Rodeo	99	
Roosevelt, Eleanor	33	
Roosevelt, Eleanor	114	
Sabbath	105	
Sabbath Services	66	
Scrolls of the Law	76	
Shalom	54	
Shalom (Stamp)	82	
Shalom (Stamp)	33	
Shavout	107	
Sh'ma Yisroel	65	
Silver, Rabbi Abba Hillel	117	
Simchat Torah	57	
Simchat Torah I	73	
Simchat Torah II	70	
Simeon	57	
Soldier at the Wall	80	
Songs of Songs I	90	
Song of Songs II	91	
Sukkah	57	
Three Graces	94	
Triumph at Entebbe	61	
Under the Chuppa	22	
V'Havta	59	
Woman of Valor	60	
Woman of Valor	110	
Zayde's Blessing	13	
Zebulon	57	

Acheson, Dean 51
Allen, Gracie 43
Arbuckle, "Fatty" 44
Arliss, George 19
Barrymore, Ethel, John and Lionel . . 25
Barrymore, Lionel 24
Bellamy, Ralph 43
Beery, Wallace 48
Bennett, Joan 43
Benny, Jack 19
Blondell, Joan 42
Boren, Lyle 25
Boroh, William 47
Burns, George 43
Cagney, James 42
Calhern, Louis 42
Cantor, Eddie 44
Cimarron . 20
Claypool, Harold K. 51
Colbert, Claudette 45
Cronin, Joe 42
Curtis, Charles 47
Dawes, Charles G. 47
Demuth, Peter J. 50
Dixon, Joseph A. 51
Douglas, Fred J. 50
Durante, Jimmy 18
Einstein, Albert 41
Gable, Clark 45
Garbo, Greta 18
Garner, John Nance 46
Garrett, Clyde L. 50
Gaynor, Janet 45
Gieseking, Walter 41

Harrington 51
Hopkins, Miriam 43
Howard, Leslie 43
Izac . 50
Jolson, Al 21
Kennedy, John F. 49
La Follette, Robert M. Jr. 46
Laval, Pierre 24
March, Frederick 43
March, Frederick 48
Mellon, Andrew 49
Ritchie, Albert 46
Smith, Alfred E. 46
Smith, Clyde H. 50
Smith, Kate 19
Shearer, Norma 43
Truman, Harry 27
Walker, "Jimmie" 46
Walter, Bruno 41
Wells, H.G. 21
White, Dudley A. 51